Dramatic Light

Paint eye-catching art in watercolor and oil

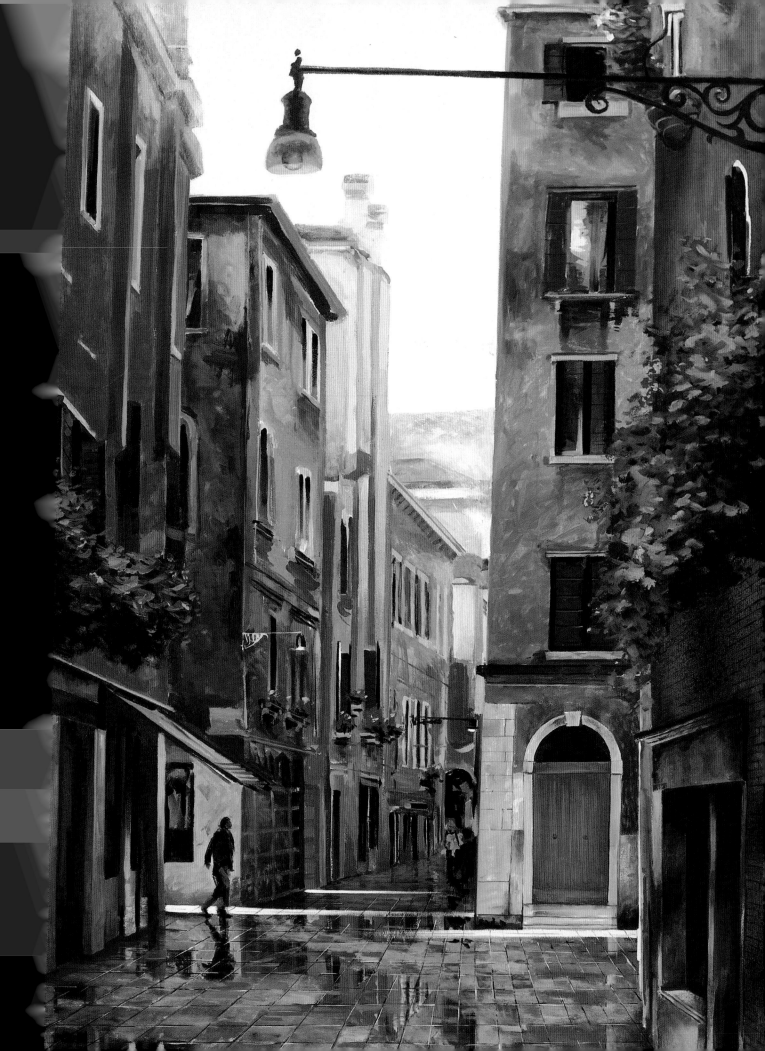

Dramatic
LIGHT

Paint eye-catching
art in watercolor
and oil

Patrick Howe

Venice Street
Oil on canvas
48" × 32" (122cm × 81cm)
Private collection

NORTH LIGHT BOOKS
CINCINNATI, OHIO
www.artistsnetwork.com

About the Author

Patrick Howe had his first one-man show in a bank lobby in Portland, Oregon, at the age of fifteen. A graduate of the Museum Art School in Portland, Patrick went on to serve as head preparator for the Portland Art Museum and to conduct workshops and classes throughout Colorado for the Colorado Council on the Arts and Humanities (CCAH). Patrick has exhibited his work throughout Colorado, Washington, Oregon and California, including several one-man shows and group shows at the Portland Art Museum in Oregon and the Loveland Art Museum in Colorado. He's an eclectic artist as well as an award-winning art director who has produced outstanding logos, calligraphy, illustrations and brochures for several Fortune 500 companies including Microsoft, Hewlett-Packard, Nintendo of America, Weyerhauser, Boeing, Eddie Bauer, REI and Princess Tours. His paintings are featured in the book *American Collector* (Alcove Press). Patrick lives in Seattle where he continues to paint. To learn more, go to: www.patrickhowe.com.

fw
f+w publications, inc.

Other fine North Light Books are available from your local bookstore, art supply store or direct from the publisher.

Adobe and Adobe Photoshop are either registered trademarks or trademarks of Adobe Systems Incorporated in the United States and/or other countries.

10 09 08 07 06 5 4 3 2 1

DISTRIBUTED IN CANADA BY FRASER DIRECT
100 Armstrong Avenue
Georgetown, ON, Canada L7G 5S4
Tel: (905) 877-4411

DISTRIBUTED IN THE U.K. AND EUROPE BY DAVID & CHARLES
Brunel House, Newton Abbot, Devon, TQ12 4PU, England
Tel: (+44) 1626 323200, Fax: (+44) 1626 323319
Email: mail@davidandcharles.co.uk

DISTRIBUTED IN AUSTRALIA BY CAPRICORN LINK
P.O. Box 704, S. Windsor NSW, 2756 Australia
Tel: (02) 4577-3555

Library of Congress Cataloging in Publication Data
Howe, Patrick, 1951-
 Dramatic light : paint eye-catching art in watercolor and oil / Patrick Howe.– 1st ed.
 p. cm.
 Includes index.
 ISBN-13: 978-1-58180-658-8 (hardcover : alk. paper)
 ISBN-10: 1-58180-658-2 (hardcover : alk. paper)
 1. Painting–Technique. I. Title.
 ND1500.H68 2006
 751.42'2–dc22 2005024072

Edited by Mona Michael
Designed by Guy Kelly
Production art by Barb Matulionis
Production coordinated by Mark Griffin

Metric Conversion Chart

To convert	to	multiply by
Inches	Centimeters	2.54
Centimeters	Inches	0.4
Feet	Centimeters	30.5
Centimeters	Feet	0.03
Yards	Meters	0.9
Meters	Yards	1.1
Sq. Inches	Sq. Centimeters	6.45
Sq. Centimeters	Sq. Inches	0.16
Sq. Feet	Sq. Meters	0.09
Sq. Meters	Sq. Feet	10.8
Sq. Yards	Sq. Meters	0.8
Sq. Meters	Sq. Yards	1.2
Pounds	Kilograms	0.45
Kilograms	Pounds	2.2
Ounces	Grams	28.3
Grams	Ounces	0.035

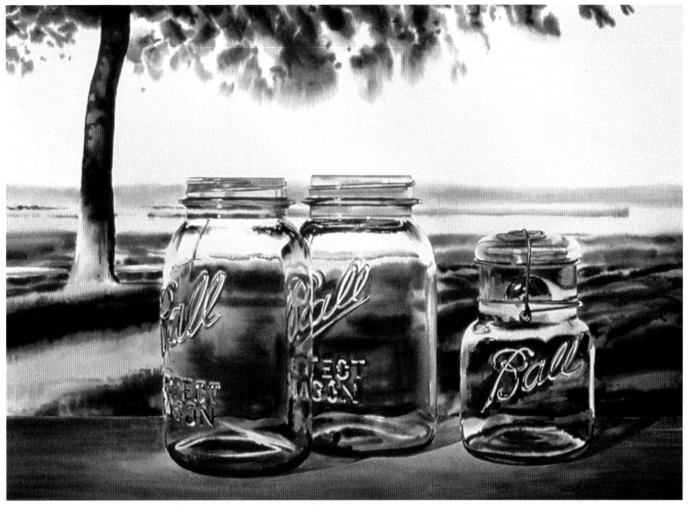

Jars at Golden Gardens
Watercolor on Arches 140-lb. (300gsm) cold-pressed
28" × 18" (71cm × 46cm)
Private collection

Acknowledgments

I would like to thank these people for their contribution to my life and career as an artist, past and present: My seven brothers and sisters (Lary, Kelly, Steve, Colleen, Molly, Michele and Tigue) for their unending faith in me; Sally, for insisting I do something with my talent; all of my art instructors, who held me to my potential regardless of my naiveté; Lee Machado for the example of her artful life; Sheena Veda and Tanya Robinson for their support and patience while enduring life with an artist; my artist buddies Dean Nettles and Martin Westermann for all the bike rides, beers and psychotherapy; and to Lilli Ann and Clair, for being such great fans.

Dedication

It is with the greatest pleasure that I dedicate this book to Victoria Smith—my inspiration, my fire.

Contents

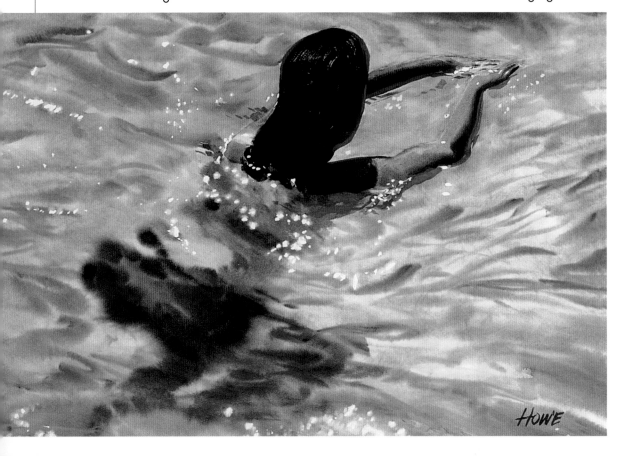

Howe

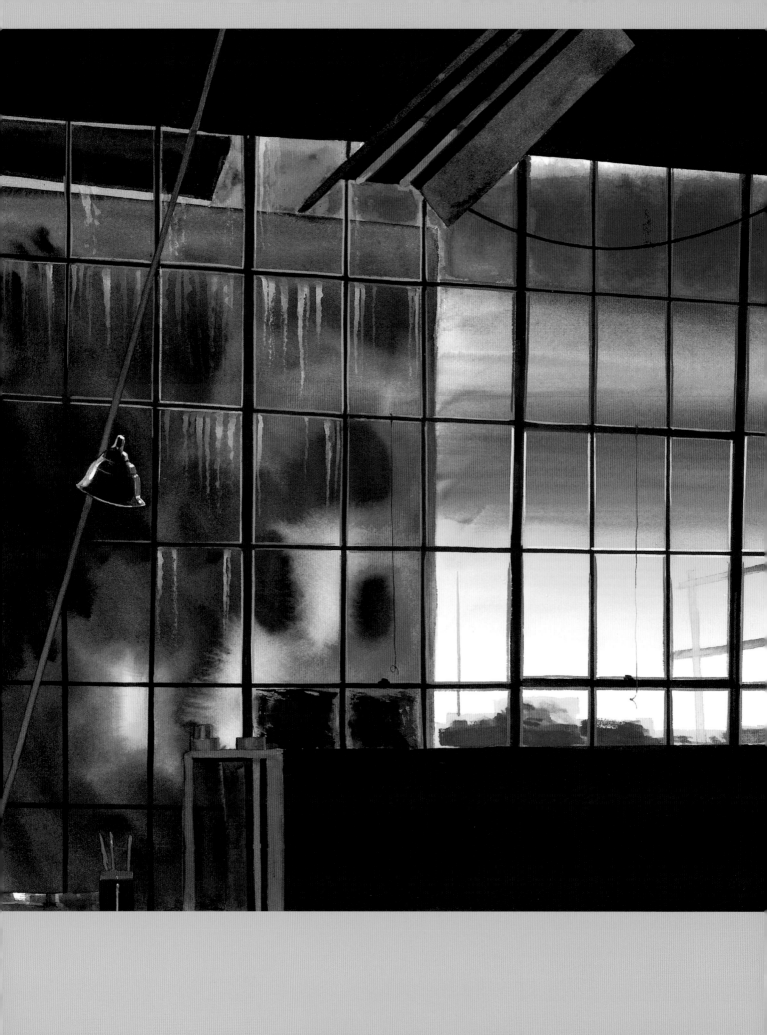

Introduction

The study of painting can be divided into four basic areas: technique, composition, color and subject. It's possible to learn about each individual area without special knowledge of the others. I believe that focusing on only one part at a time simplifies the learning process.

Here I'll focus on technique and downplay the other basic areas of learning that comprise a complete work of art (composition, color and subject). This way, you'll be able to study technique without the distraction of other elements.

Some art instructors teach only how easy and joyous painting is. I'm here to tell you that while it is joyous and sometimes feels easy, it's often an intensely focused experience. But it's that intensity that tells me something good is happening. Other times, painting is meditative. The creative flow carries away the troubles of the world, and my heart is at peace.

When things are made, either in nature or art, it's sometimes a messy and uncomfortable process. The satisfaction often comes later, in retrospect. For me, the creative process is a way of growing artistically, intellectually and spiritually, while having fun.

In your light I learn how to love.
In your beauty, how to make poems.

You dance inside my chest,
Where no one can see you,

But sometimes I do,
And that sight becomes this art.

-Rumi

Studio Nights
Watercolor on 140-lb. (300gsm) cold-pressed
28" × 20" (71cm × 51cm)
Private collection

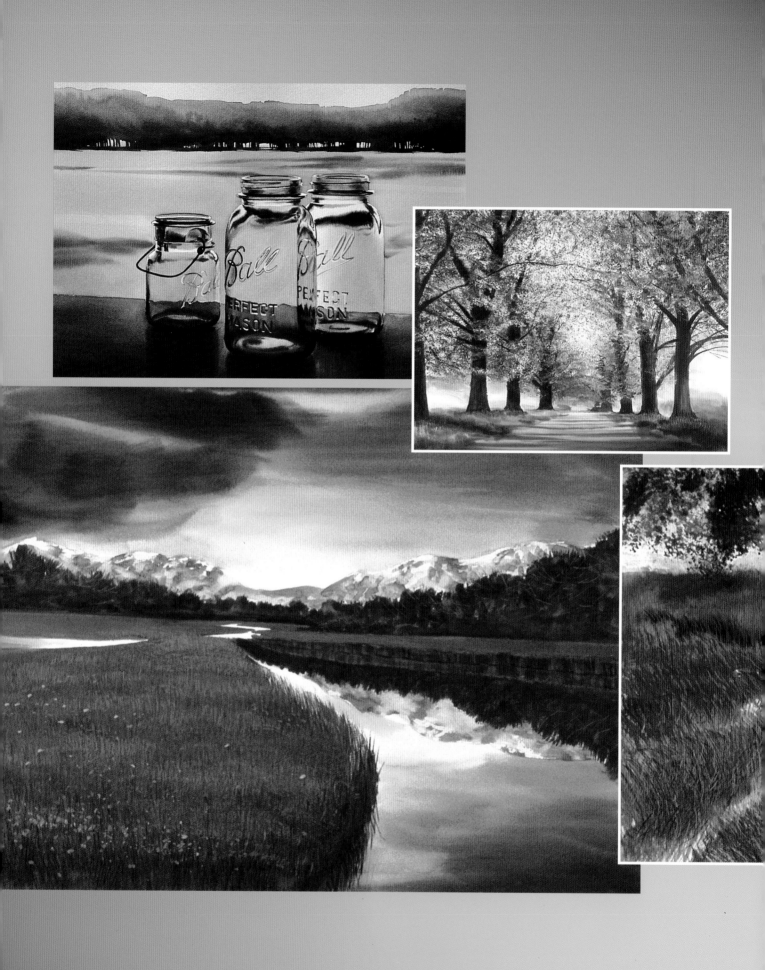

1

Preparing and Planning

The most important thing to remember as you proceed is to have patience with yourself. It always takes a little time to get up to speed with any new skill. Go slowly and enjoy the process.

Before you paint a picture, you need to get situated with some basic tools, supplies and techniques that will make your job a lot easier and more fun. In this chapter you will learn fundamental information that all artists need to know before painting any work of art. This phase of learning can be quite enjoyable, because it breaks down the process into bite-sized steps.

Tools and Setup

Painting is supposed to be enjoyable, but it can't be if you get a backache every time you spend an hour or two at work. To prevent discomfort, position your tools conveniently and ergonomically. Place the most frequently used items—clean water, your palette of colors and the necessary brushes—closest to your hand's reach.

Brushes

Brushes are just about the most important tools in painting, and the number of brushes to choose from can be dizzying. The rule of thumb here is that brushes tend to do what they look like. Select them according to how their bristles resemble the size, shape and texture of the strokes you wish to make.

- **Try different sizes.** While brush sizes generally are universal, slight variations occur. A no. 4 flat in a synthetic hair might be ¼-inch (6mm) wide, but a no. 4 ox hair brush made by the same company might be ½-inch (13mm) wide. It's a little like clothing sizes. Try them on before making an investment. Also, like clothes, sometimes the more worn in brushes get, the more attached you become to them. Their age produces unique marks that you come to rely on for one-of-a-kind performance.

- **Cost doesn't equal quality.** Buying expensive brushes won't necessarily make your painting better. Most effects can be achieved with inexpensive brushes.

- **Brush longevity varies.** Some brushes will last over a decade, and others (especially oil brushes) are destroyed after only a painting or two.

Watercolor Setup

I am left-handed so I position my tools on my left side.

Liquid mask

Paper towels

Current colors

Back up colors not being used on the current painting but kept handy

Gouache for touching up highlights

Dirty water tub to clean brushes while painting

Clean water tub

Plastic palette for paint mixing

Brushes Do What They Look Like

- **Long skinny** brushes make long skinny lines.

- **Square** brushes make rectangles or floating ribbon-like marks when you twist them between your fingers.

- **Sumi-e/calligraphy** brushes make thick, thin, pointed and rounded shapes.

- **Bristle** brushes make stiff, scratchy marks and leave bristle marks.

- **Stiff flat brushes** act like squeegees and tend to scrape the paint onto the surface, leaving a thinner layer.

- **Soft, loose-haired** brushes behave like mops and leave no stroke marks.

Toothbrush for splattering paint

Backup brushes

Hakes (top) or chip (bottom) brushes for large washes

Brushes being used on current painting, pointing downward for easy reach

How to Prepare Oil Paints for Use

At first just use the paint straight off the palette without any medium. Monet painted his famous water lilies using this technique. Mediums generally produce thinner layers. Painting without them will give you a thick look for great textures and rich colors when dry. When finished, clean the brush with odorless mineral spirits.

Once you've gained some experience, put a little oil medium in a mixing jar and add about 10 percent or so of odorless mineral spirits (guessing's close enough). Stir well. Mix a little of this concoction into your paint as you go. The colors will be rich, saturated and slippery. Thin layers of this glaze look great over existing layers of paint too.

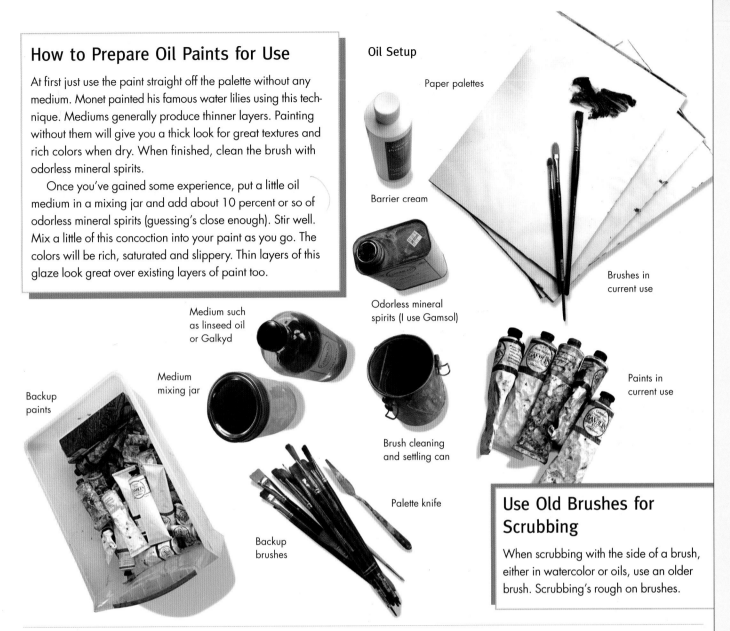

Oil Setup

Paper palettes

Barrier cream

Medium such as linseed oil or Galkyd

Medium mixing jar

Backup paints

Odorless mineral spirits (I use Gamsol)

Brush cleaning and settling can

Palette knife

Backup brushes

Brushes in current use

Paints in current use

Use Old Brushes for Scrubbing

When scrubbing with the side of a brush, either in watercolor or oils, use an older brush. Scrubbing's rough on brushes.

Palette

No matter what type of palette you use, make sure it's white so you can clearly see your pigments. I use disposable paper instead of a palette for oil painting. I don't care for scraping old encrusted paint off a traditional nondisposable palette.

Paints

I use Gamblin oil products because their solvent and mediums are less toxic than other brands. Look for mediums and products that are designed to work together, are lead-free and have smooth working properties.

When shopping for watercolor paints, select only quality brand names. (I use Winsor Newton exclusively). You can trust that their pigments will blend well and their colors will be brighter than student grade paints. Ask your art supplier for advice.

Mediums

A medium is something added to paint to alter it for some effect. Different combinations of mediums can make paint thicker or thinner, can increase or decrease glossiness, even speed up drying.

Some mediums break down the structure of paint, and others strengthen it. *Solvents,* such as odorless mineral spirits and turpentine, thin or break down the paint for a more slippery or transparent look. Because solvents break down the actual structure of the paint, never use more than 10 percent solvent in your mixtures for thinning.

Oils, such as linseed oil and Galkyd, strengthen the paint to produce special effects such as glazes and textures while retaining color intensity. Remember it this way: Solvents weaken paint, oils strengthen it.

What to Paint On

Watercolor and oil paints require different surfaces. For watercolor, you'll use hot-pressed, cold-pressed or rough papers. *Hot-pressed* paper is so smooth that pigment doesn't absorb into the paper. Because of this, you can get interesting splotchy and mottled qualities. *Rough paper* has lots of texture that holds on to the paint. You can use the rough texture to simulate surfaces such as tree trunks or rocks. However, it's not as convenient for tight or technical painting. *Cold-pressed paper*, used in the demonstrations throughout this book, has a medium texture. I tend to use 140-lb. (300gsm) cold-pressed more than any other because it's an all around workhorse. It's neither too smooth nor too rough. I can achieve more effects with it than any other paper; it's good for smooth blends and sharp lines as well as textures.

For oils, you usually need canvas. Canvas usually involves stretching, and that's still a low-tech activity. You stretch canvas today in much the same way as people did hundreds of years ago. Still, you have some choices.

- **Prestretched preprimed canvases** are relatively inexpensive and require no assembly. The drawback is that you are limited to only a few sizes, and the canvas is never stretched tightly enough.

- **Stretch your own, preprimed or raw, canvas** with wood stretcher bars. *Stretcher bars* come in many sizes and are fairly easy to assemble. After stretching, you coat raw canvas with *acrylic gesso*. (Apply three coats of the gesso with a brush, sanding the surface lightly between coats.) You can stretch the raw canvas as tightly as you want, in any size and proportions you want. It's less expensive, but time consuming. You'll also have to buy a hammer, pliers and stapler if you don't already have them, and the act of stretching requires physical strength.

- **Canvas board** consists of a piece of board with canvas glued over it. It is less expensive than stretched canvas, but the surface has less flexibility.

- **Boards** are mahogany paneling attached to a frame. You can get a very smooth surface for detail painting that is difficult to do on canvas. The wood makes paintings considerably heavier, however.

- **Stretched watercolor paper** prepped with a layer of gesso can receive oil paint. These paintings are easy to handle because they are on flat paper, though framing is required.

How to Stretch Watercolor Paper

If you don't stretch your watercolor paper before painting on it, the paper will warp. If you're trying to create smooth blends, warping is not a good thing. To stretch your paper:

First, **soak** the paper in a bathtub for about a half hour. **Remove** the paper from tub. Let water **drip** from the paper until it no longer drips. **Lay** the paper on a stiff board (A). I use Gator-board (a stiff, lightweight, Styrene foam sandwiched between composite sheets). **Apply** a bead of glue along the edge of the paper to be taped. **Wet** the gummed paper tape and **affix** the watercolor paper to the board (B). You've got some extra room now to allow your paint to slop over the edges of the tape (C), giving you more freedom as you paint.

A

B

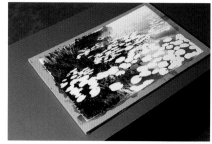

C

Four Degrees of Paper Wetness

Exactly how wet is *wet*? Different degrees of paper wetness cause the paint to do different things. You can achieve beautiful edges and blends as you learn to create and use the four states of paper wetness: high gloss, semigloss, satin and eggshell sheens.

High Gloss

When paper is flooded with standing water, very little of its texture is visible when light reflects off it. The pigment drifts away and is uncontrollable. Interesting effects can occur, but a high gloss paper wetness is not generally used in watercolor painting.

Try It

Wet a piece of watercolor paper and position yourself so you can see light reflecting from the wet paper. Then, using any brush, paint stripes that capture the four stages of paper wetness.

Semigloss Sheen

This is very wet, but the texture of the paper is clearly visible when light reflects on it. It's an excellent condition for large washes and broad blends of color.

Eggshell

This is the condition in which the water evaporates to the point where the paper looks dry but isn't. When touched with a brush a beautiful irregular edge appears.

Satin Sheen

The paper is slightly drier than the semigloss condition. The surface reflects tiny pinpoints of light. This is a smooth silky sheen that produces tight blends. The pigment does not disperse very far.

Dry Paper

This paper, of course, is not wet, which is the best condition when you're going for hard edges with watercolors. (See page 18.)

Color Basics and Transparency

In theory, mixing *primary* colors together creates the *secondary* colors. But in reality the chemical attributes of pigments result in colors that can become muddy when mixed. To create truer secondary colors, manufacturers make them, along with other difficult color mixtures.

What primary colors can do, however, is naturally create the look of transparency. Simply layer one primary over another to create the illusion that the colors are transparent.

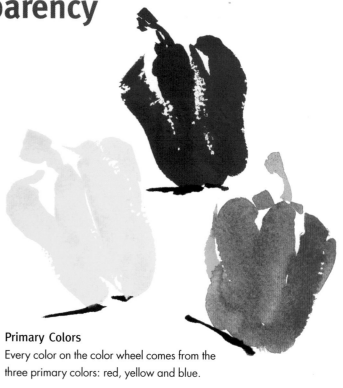

Primary Colors
Every color on the color wheel comes from the three primary colors: red, yellow and blue.

Secondary Colors and Complements
Mix two primary colors together and you'll get secondary colors: orange (red + yellow), green (yellow + blue), and purple (red + blue).

On this wheel you also begin to see *complementary* colors (colors opposite one another on the color wheel).

For More About Color

Check out *Color Harmony in Your Paintings*, by Margaret Kessler or *Exploring Color, Revised Edition*, by Nita Leland.

Layering Primaries Creates Transparency
When you need a straight, true pigment, it's best to purchase the tube of paint from the manufacturer.

Red + Yellow

Red + Blue

Blue + Yellow

Orange straight out of the tube

Purple straight out of the tube

Green straight out of the tube

The Three Aspects of Color

Descriptions of color vary from expert to expert. The language can be confusing, the words interchangeable. Archaic terminology sometimes commingles with contemporary terminology. Here are aspects of color I use to create light-filled paintings.

Hue

Hue is the color of the color, so to speak. When there's a change of hue, there's a change of color.

Saturation

Saturation is the intensity of the hue. You can decrease the saturation of a hue by adding the hue's complement (see page 16). For instance, to get a less saturated or duller green, you would add red to the green until it reaches the exact saturation you want.

Value

Values are the different tints and shades (lightness and darkness) possible with a hue. You create tints by adding white to a color. (With watercolors, you create the tints by adding water, not white, to the color.) You create shades when you add black to a color.

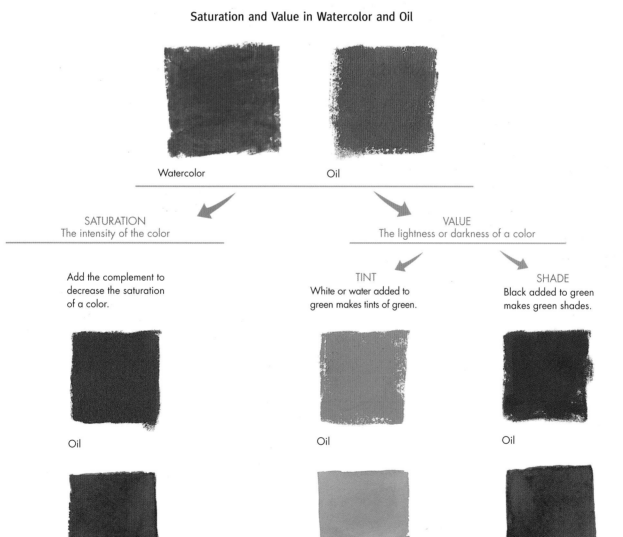

Saturation and Value in Watercolor and Oil

Watercolor Oil

SATURATION
The intensity of the color

VALUE
The lightness or darkness of a color

Add the complement to decrease the saturation of a color.

TINT
White or water added to green makes tints of green.

SHADE
Black added to green makes green shades.

Oil Oil Oil

Watercolor Watercolor Watercolor

Basic Watercolor Painting Techniques

Watercolor has a finicky and delicate nature. With oils you can squeeze the paint straight out of the tube and start painting. But you wouldn't go very far by squeezing watercolor pigments straight out of the tube. Watercolors require water, and water changes everything.

I use three basic watercolor techniques:
- **Wet-on-dry:** Each layer of paint is applied to the dry paper and allowed to dry before applying another layer of color.
- **Wet-on-wet:** The paper is wetted first, and then color is added.
- **Wet-to-dry:** You start with wet paper and continue painting until the paper is dry.

Wet-to-Dry
As the paper dries, paint the progressively harder shapes until you end up painting wet-on-dry.

Wet-on-Dry
This technique is perfect for showing hard edges. You will use this technique when you paint hard-edged patches of light.

Try It

Paint a small painting using the wet-to-dry technique. Incorporate into the painting each stage of paper wetness, starting with high gloss. As the paper dries, paint the areas that require a satin sheen, eggshell sheen and finally, those areas that are best painted wet-on-dry (dry paper).

Wet-on-Wet
When you are trying to achieve soft blends of color or soft textures, this is the technique to use. (I used wet-on-dry on the chick to paint the feet, eyes and beak). This technique automatically gives the chick a soft diffused light all around. Any blend that fades into the white of the paper will produce a soft glow, as if there is light around it.

Begin With One Brush, One Color and Simple Shapes

The best way to begin and practice watercolor technique is to focus on simple, one-color shapes. The shape of a subject was thought by Zen painting masters to reveal its essence and its underlying nature. Round, amorphous or blob-like shapes are the most fundamental in watercolor painting because that's the natural shape water assumes.

In this exercise, you don't need to draw your subject beforehand. Start directly with the brush, letting it "become" the subject you're painting. As you gain facility with subjects of simpler shapes, proceed to more complex shapes.

Use the wet-on-dry technique for this exercise. It is not only the easiest to master, it produces wonderful shapes.

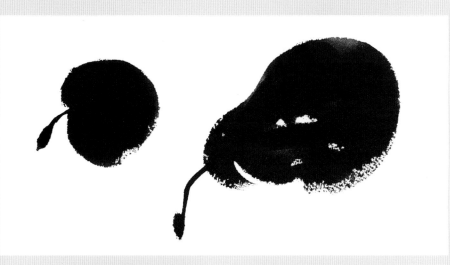

Paint Simple Shapes

Find objects to paint around your house (kitchens are great for this) or in books and magazines. The only concern for this exercise is that the shape you paint resembles the subject somewhat. If it doesn't on the first try (it rarely does), repeat the exercise until it does. The first subject I painted was a bell pepper. I painted it many times before it began to resemble a pepper.

How to Select Brushes

In general, use wider brushes at the beginning. Switch to broad strokes and narrower brushes toward the end for details. Always select brushes by how their bristles resemble in appearance the size, shape and texture of the brush-strokes you wish to make.

Add Color to Your Shapes

If the essence of a subject is found in its shape, then the life of a subject is most certainly found in its color. Now that your shapes look somewhat like their subjects, begin adding color to them.

Don't worry about shading or highlights for this exercise. Concentrate only in maintaining the shape of your subjects and adding colors to them.

If you practice this exercise often, it will build up your perceptual ability, which in turn will help you see the shape and color of subjects.

Look It Up

Henri Matisse took painting simple shapes to the level of mastery. To see examples of his work, go to www. google.com, select Images, enter Matisse, then click Search.

Begin Adding Color
Paint a pepper green with a little green paint mixed with a little water. Before it dries (wet-on-wet), add red and yellow into the pepper shape and watch what happens. Repeat the exercise with other simple objects.

Creating Positive and Negative Shapes

In representational art most subjects have a surrounding. The shape of the subject is referred to as the *positive shape* and the surrounding area as the *negative shape*.

Imagine a solid red chair against a green wall. The red chair is a positive shape and the green wall behind the chair, including the green wall visible between the legs of the chair, are all negative shapes. Simply, a negative shape is anything that is not a positive shape.

In watercolor painting, positive and negative shapes often divide also into water and anti-water shapes. *Water shapes* tend toward the more rounded and soft because pigment in water will always disperse in the shape of a circle or combinations of circles, forming amorphous blobs. *Anti-water shapes* require tighter or sharper points or edges. You will want to use smaller brushes, dryer paper, and less wet pigment for these to help reduce the dispersal of the paint and give you more control.

As a surrounding, light is often best represented as a negative shape because the light usually moves in and around solid objects, which are the positive shapes.

Anti-Water Shapes Require More Effort
The quintessential anti-water shape is a spiked star, because when covered with water, the pigment will want to disperse in a shape that is its opposite, the circle.

Water Shapes Come Naturally
Watercolor loves round subjects. The most natural water shape is the circle.

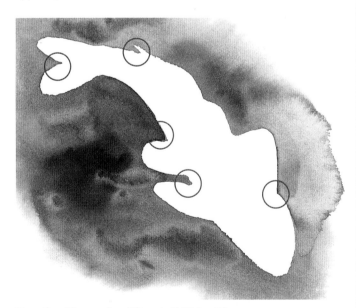

Negative Shapes Are Often Anti-Water Shapes
The shape around a subject is called the *negative shape* (or *negative space*). Most negative shapes are also anti-water shapes because they contain points. Hence, the background surroundings of your paintings often require that you become proficient at creating anti-water shapes. Use a small brush where there are triangle-like shapes or sharp points.

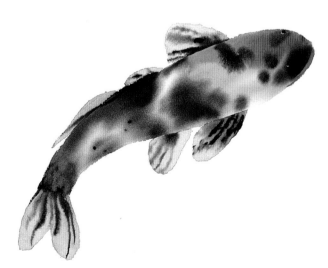

Positive Shapes Are Often Water Shapes
Positive shape is the shape of the subject of your painting. This golden carp is basically composed of six water shapes (the body, four fins, and a tail). When you have a series of shapes that form a subject like this, paint each separately and allow each to dry so the paint doesn't bleed.

Create Depth With Overlapping Shapes

By overlapping objects (rather than drawing or painting them with space between them), you create the basic illusion of foreground and background. The general principles for using overlapping objects to create depth in two-dimensional art are true for every painting medium.

- Foreground objects always appear larger than background objects.
- Foreground objects are usually positioned below background objects on the paper or canvas.
- The closer objects are to the horizon, the lighter and more muted they appear. Therefore, the foreground object will have the brightest, most saturated colors, and the objects farthest away will have lighter and less saturated, muted colors.
- More details appear in the foreground, fewer in the background.
- Edges appear sharp and hard in the foreground and soft and blurry toward the background.

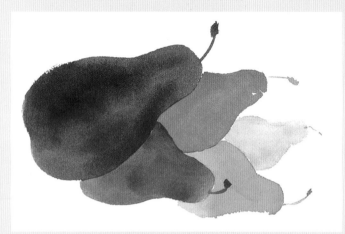

Practice Overlapping With Watercolors

1 Draw a light outline of simple objects, such as these pears, overlapping.
2 Apply the lightest colors first. Start with the background pear and progress to the foreground.
3 Use a lot of the color to paint the foreground pears.
4 Let each pear dry before proceeding to the next to avoid colors bleeding into their neighbors.

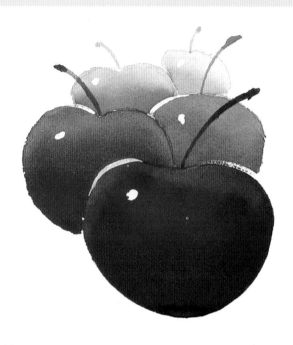

Incorporate Gradient Tints

Use the overlap technique to paint these cherries. Make each cherry lighter at the top and darker at the bottom. This is a simple way of showing form without dealing with the issue of a realistic light source. Use white gouache to create highlight reflections. The farthest cherry should almost disappear into the whiteness of the paper.

Three Basic Edges Help Create Depth and Add Light

There are three basic types of edges in watercolor painting: layered, blended and butting (also called knocking).

Layered edges work very effectively when you have a light background, such as a sky, which can be painted over. Hints of the background color will show through, adding color and dimension to the object you're painting. It's also perfect for showing a subject in silhouette against a bright light.

Butting edges knock together, some places overlapping a little and other places not quite touching. This irregularity energizes the edge, making it appear to catch light and sparkle.

Blended edges appear fuzzy and out of focus. They are perfect for showing diffused light, such as fog or mist.

Use Wet-On-Dry for a Layered, Sharp Edge
To create sharp edges, begin with a wash and allow it to dry. Paint the shape over the dry layer. The layering of washes creates hard edges in watercolor. This effect is well suited for showing a strong contrast between a bright light and an object in silhouette.

Use a Satin Sheen to Get Blended, Soft Edges
Allow your first wash of paint to dry as before. Then, apply a wash of water over that dry layer. When the paper is almost dry (satin sheen, page 15) paint the shape, allowing its edges to bleed somewhat. Use this technique to show an object in the distance or to create a soft, misty quality.

Paint Each Shape Separately for Butting Edges
When you paint shapes individually without layering, you get butting edges (also called knocking edges). The edges seem to knock together, meeting like two puzzle parts. This technique works best wet-on-dry, and is excellent for creating the look of shimmering light.

Enlarge Without a Measuring Tool

There are several methods for enlarging photos or sketches. I most often use the method shown here because it's fast, accurate and low tech. It is completely visual, and visual artists love visual solutions that require no measuring tool.

Watercolor Paper

1 | Create a Grid on Your Reference Photo
Use a pen, pencil or craft blade to draw a grid pattern on a reference photo.

2 | Attach the Photo to the Surface
Tape the photo squarely in the upper left corner of your painting surface.

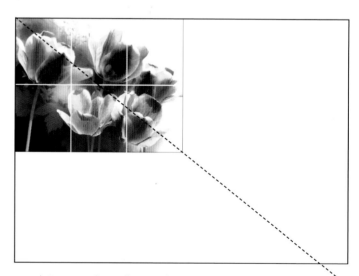

3 | Draw the First Diagonal
From the upper left corner, draw a diagonal line through the bottom right corner of the photo to the outside edge.

4 | Draw the Border of Your New Image Size

From the point at which the diagonal line intersects the edge of the paper, draw a vertical line. This new square will have the same proportions as the reference photo.

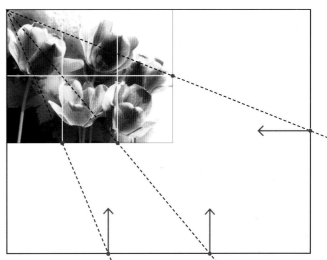

5 | Locate the Line Positions

As in step 3, project lines from the upper left corner through the lower right corners of the photo's grid squares. Extend the lines to the edges of the new larger proportioned square drawn on the paper.

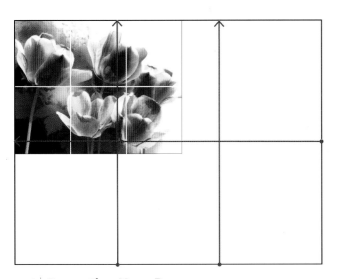

6 | Draw the New Boxes

From the points where the diagonal lines touch the edge of your new larger square, draw horizontal and vertical lines.

Do You Stand or Sit?

Some believe if you stand while painting, your strokes will be more active, while sitting produces calmer strokes. Experiment to see what is true for you. As a matter of convenience, I always sit while watercolor painting and stand when painting oils larger than about 36" × 36" (91cm × 91cm). Having comfortable shoes and a patch of carpet to stand on helps. If my feet get tired, I rearrange my setup so I can continue painting while sitting. Comfort and convenience are important.

Create a Grid Drawing

Dividing your reference image into smaller squares is a method of simplifying the enlargement process. It was developed and used by Renaissance masters and is used widely today by many of the best contemporary artists.

With this method, you subdivide the reference image into a grid pattern of equal size squares. Then you draw a corresponding larger pattern of grid squares on your painting surface. From there you draw what you see in each square. It's based on the fact that it's much easier to draw several small and simple pictures than it is to draw one large complex picture. Try it; it works.

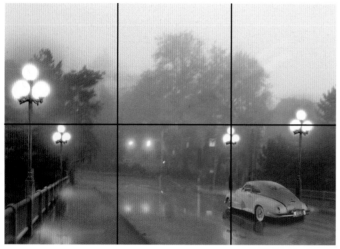

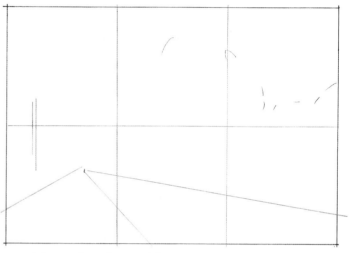

1 Draw a Grid

Draw a grid on your reference photo or sketch. If possible, identify the vanishing point using projecting lines. The *vanishing point* is where all the lines in your drawing or painting recede to. Here I used the lines of the curbs to find the vanishing point.

2 Transfer the Grid

Transfer the grid lines to your paper, board or canvas using the enlarging method on page 24. Draw the lines you see in each grid box, beginning with the longest ones. Shorter lines are more difficult to misplace if the longer lines are placed correctly first.

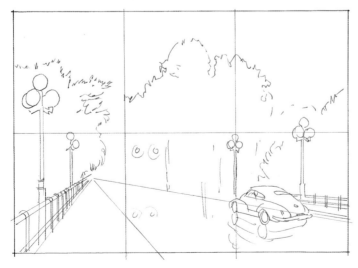

3 Add Details

Add the smaller detail lines. Again, focus on the shapes you see in each box.

Painting From Photos

I still hear some artists say, "Oh yes, I use a camera but only for reference," as if using a camera is cheating. To them I say, "Get with the twenty-first century!" Focus more on your ideas and less on how you arrive at them.

The photos you use for reference help you express your composition, your viewpoint, your subject matter and your choice of lighting and color. Half the work is done in a fraction of the time it would take to sketch the same scene by hand. Being practical is never cheating.

There are two main rules of thumb you'll want to follow, though. First, get your film professionally developed. You want the colors in your references to be true, and it's difficult to guarantee that at quick-print places. Second, don't follow your photos blindly. Use them for reference only. It's *your* painting; choose what you like from your picture and throw out the rest.

How to Use Your Photos

Use your camera as a sketching tool to help you generate ideas. You may modify the painting extensively from the photo, or if the photo captures exactly what you want, you can follow it more literally. Feel free to combine ideas from two or three photos into one painting.

Even out of focus or poorly developed photos can be excellent reference images because of the interesting and unexpected effects they offer. Give your photos time to grow

on you. You always have the option of altering them on the canvas. However, the camera is merely a tool. Use it if it helps express your ideas. If it doesn't, move on to methods that do. The important thing is to let your ideas grow and let whatever art-making process you use follow your curiosity.

Incorrect photo processing

Correct photo processing

Choose a Professional Photo Processor
The greenish photo was printed at a one-hour, quick print place. A professional photography lab printed the same photo with drastically different results.

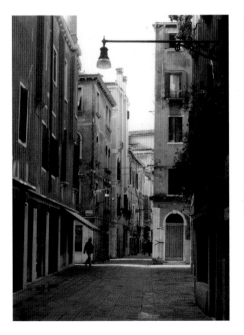

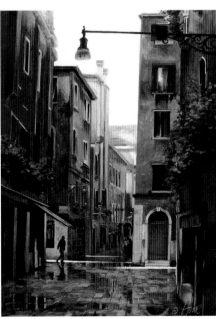

Take Your Art Beyond the Limits of the Camera
Photos are for reference. That means you can copy them very literally or use them as general guides. I based this painting on the photo, but added a rainy street, more shadows and brighter colors to the painting.

Use Digital Cameras for Convenience

If you are serious about using a camera as an image reference tool, I highly recommend a digital camera. (I use a 3.2 megapixel Minolta Dimage Z1). For reference photos, most digital cameras do everything a conventional camera can, and more. The main advantage is that you can review images immediately through a built-in viewing screen. That means you can decide whether you like the picture without having to wait for (and pay for) film processing. A built-in zoom lens is also handy because it expands your selection of scenes, compositions and subject matter.

Photo Manipulation

Digital cameras are especially advantageous if you are familiar with computers. You can upload images from your camera to your computer, manipulate them and print them out on a color printer. Most digital cameras come with elementary photo manipulation programs that enable the user to crop, change colors and perform other basic modifications. Do some research and talk to a knowledgeable salesperson to make sure you're buying the right camera for your needs.

A

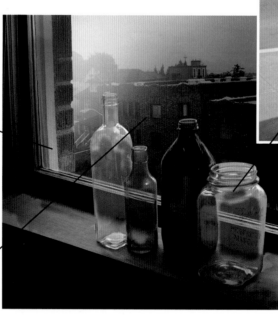
B

Basic Photo Manipulation
Photo A is an original digital photo taken near my studio. Photo B is the same photo uploaded to my computer and manipulated in just a few minutes with software that came with the camera.

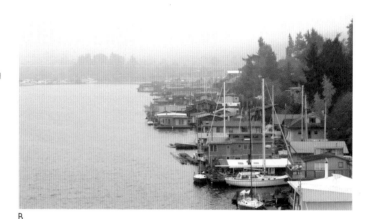

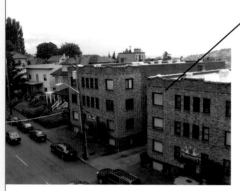

Digital Sketching
You can combine several reference photos to create one great painting without a digital camera. However, with a program like Adobe® Photoshop® you can merge the photos together to create a single strong image that you can print out and use as a reference. This way, you can see the complete composition before you draw or paint it.

Composition

Composition is the arrangement and relationship of elements in a painting or drawing, not unlike arranging the décor in a house. The rules of good composition have evolved through the centuries to the point where today almost anything goes. However, there are still guidelines to follow:

- Use *arrows* (perspective lines that lead the viewer's eye through the painting) thoughtfully.
- Avoid symmetry.
- Avoid *tangents* (lines that touch without overlapping).
- Avoid dead ends.
- Avoid placing objects too close together.

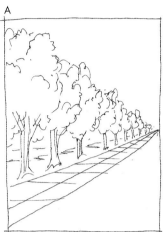
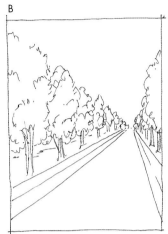

Perspective Lines Create Arrows

Use arrows thoughtfully. In drawing (A), tree perspective lines form an arrow that slams the eye against the right edge of the drawing. Drawing (B) has a counterbalancing arrow that helps lure the eye down the road.

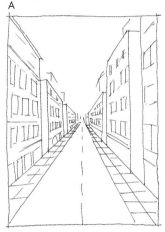
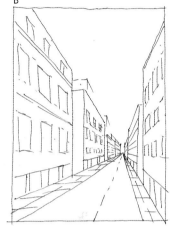

Avoid Symmetry

The vanishing point in drawing (A) is in the exact center of the paper. This placement makes the arrows created by the perspective lines point to the center and decrease spatial depth. Position your vanishing point asymmetrically, as in drawing (B), for pleasing dynamic tension and greater spatial depth.

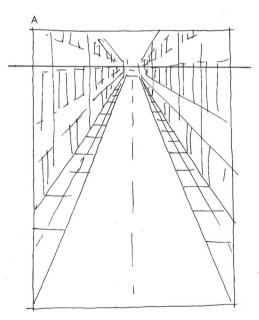
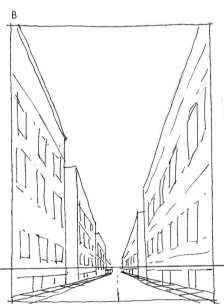

Position the Vanishing Point

A vanishing point positioned high in the picture (A) flattens the image, and the viewer is encouraged to look at the larger and most dominant element (the street). Position the vanishing point toward the bottom edge (B) to encourage the viewer to look up toward the sky and to create greater spatial depth.

Where to Look for Composition Ideas

Good dramatic movies use all of the tried and true compositional devices that rivet attention. Watch movies with the sound off and pause the DVD on scenes you find compositionally interesting. Go into analytical mode and ask yourself why a scene is effective. Look at its colors, values, spatial depth and point of view. I recommend studying: *Dr. Zhivago, Gone With the Wind, The Lord of the Rings* trilogy and *Girl With a Pearl Earring*. Most of the great classics have stunning compositions sprinkled throughout them.

You might also look at abstract art or art that has abstract qualities. It may not be your thing, but it can offer excellent examples of raw composition in which subject matter is secondary or eliminated altogether. Go to www.google.com. Select Images, then enter one name at a time: Matisse, Braque, Kline, Kandinsky and Klee. Click Search.

A

B

Avoid Dead Ends
A *dead end* is anywhere the viewer is drawn down a path then has nowhere to go (A). Be cautious about using a wall of trees, mountains or anything that prevents easy eye movement to other areas of the painting. In drawing (B) the eye is drawn farther into the picture.

Avoid Distracting Tangents
The bumper of the car touches the woman's arm and draws attention to it unnecessarily. It also confuses the spatial depth. The front of the car appears to exist in the foreground space with the woman, yet the rear of the car is positioned in the background.

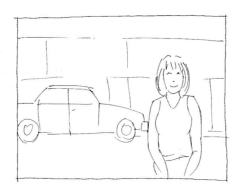

Things That Add Depth

- Asymmetry
- Low horizons
- Softer edges toward the horizon
- Subtle colors
- Smaller shapes at top and larger ones at bottom
- Larger brushstrokes in the front, smaller ones toward the back

Things That Flatten

- Unnecessary tangents
- Symmetry
- High horizons
- Sharp edges
- Harsh colors
- Uniform-size shapes
- Uniform-size brushstrokes from front to back

Allow Adequate Space Between Objects
Closely aligned objects create confusion about depth (A). Adequate space between objects clearly states what they are and where they are in space (B).

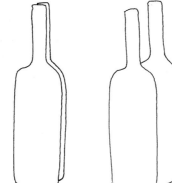

Understanding Flatness

Often when someone says a painting is flat, they are suggesting that it lacks expressiveness, color or character. But, flatness is not necessarily a derogatory description. Flatness is just another visual effect, like depth or texture.

Flatten Your Subject to See Composition

When you see your subject spatially, you view the paper or canvas as a window and look through it into a world with a foreground, middle ground and background. When you flatten your subject, you look at the same object or scene but imagine it's flat like a jigsaw puzzle. Then you can observe the arrangement and relationship of the puzzle parts. The flattened picture easily reveals those distracting compositional mistakes such as tangents, dead ends and too much symmetry (page 29).

Spatial view

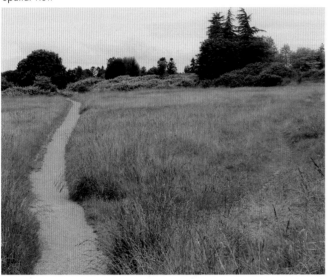

Flat view

Self-Critiquing Tips

An eye for weaknesses
What about your painting stands out? Does it weaken the painting? It's sometimes easier to identify what is weak than what is strong because weaknesses tend to jump out and poke you in the eye.

An eye for strengths
Identify the strong areas in your painting. Strong compositions form a unified, pleasing whole. Colors and values are harmonious, and the scale and relationship of shapes and objects make sense.

A new light
Take the painting to different areas of the house or outside to see how it looks in different lighting conditions.

Look in the mirror
Hold the painting up to a mirror; in its reversed image, you will immediately see any compositional inaccuracies.

Give it a break
Put the painting away for a few days to a week. When you come back and view it freshly, areas that need more work may jump out at you.

Be honest with yourself
Never assume viewers will not notice a blooper. It's better to assume the viewer sees everything. If you can see it, the rest of the world can see it too.

Break Your Subject Into Puzzle Pieces
Reducing your subject to its most basic shapes allows you to more easily analyze its composition. Looking at this subject spatially, you see the foreground path receding into the distance seemingly a few hundred yards and there's a sense of depth. But if you look at the same composition as flat, you see flat shapes, like jigsaw puzzle parts. Now you can review the composition's symmetry, edges, horizon, colors and shapes.

Use Lighter Tones On Silhouettes

You learned about hard (layered) and soft (blended) edges on page 23. These become especially important when you're dealing with silhouettes. Lighter tones used on the contours of silhouettes soften them and convey a sense of greater spatial depth. Hard-edged silhouettes look stenciled on and flatten the subject, making it look as though it is attached to the surface of the painting rather than being in the painting.

To avoid this and create dramatic light, soften the edges of the silhouetted object with hints of other tones. If a silhouette appears to be solid black, don't paint it that way. Rather, add subtle shifts of tones and suggestions of details within the area. This will help create a sense that the light behind the silhouetted object is all the more brilliant.

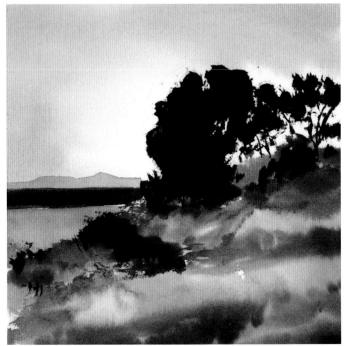

Hard Edges Confuse Depth Perception
The island in the background jumps to the foreground because it's as dark as the foreground colors and its edges are hard.

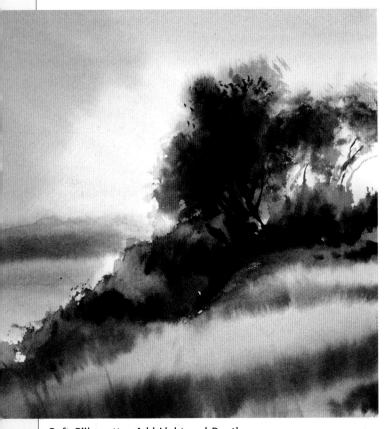

Soft Silhouettes Add Light and Depth
The island here looks more atmospheric because the colors are muted and lighter, and the edges are softened.

COMPOSITION GAMES

THE PAPER GAME

OBJECT To create a group composition based on scraps of torn paper.

PURPOSE To expand the compositional perception of the players.

PLAY Cut and tear several sheets of colored construction paper into various sizes and shapes. Give each person eight pieces of various colors. On a large white piece of paper, one by one, each player lays down a piece of colored paper. Start building a composition based on the scraps of paper laid down before you. The goal is to create a compositional design or pattern that is strong and uses all the pieces of paper. This is especially fun because you can discuss your ideas and compositional strategies as you go. Two or three teams can compete against each other or against the clock.

Zoom to Analyze Your Work

There are three levels from which to analyze and examine your artwork. To see the *whole*, zoom out to study the painting from a distance. The *story* of the painting is best told viewed at midrange. Zoom in close to see the *details* of the technique.

Zoom Out to See Composition

Strong composition always works well from a distance—as well as sideways or upside down. Forget your subject matter and focus on the relationship of lines, shapes, colors, values and spatial arrangements. In strong compositions, nothing appears out of place; all elements are integrated into a whole. In weak compositions, the flaws jump out and grate against other elements.

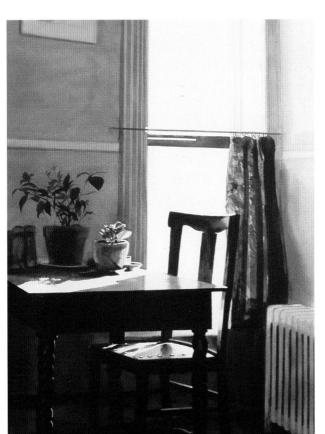

Look Midrange to See the Story

The story is what the subject is saying, the emotions it evokes or the ideas it conveys. If this kitchen scene had been painted in bright pastel tones with thick dabs of paint it would have communicated a whimsical springtime feeling, whereas done this way it tells the story of a quiet fall afternoon and conveys warmth.

Ask yourself if your story is being well communicated. Does the subject matter, composition or painting technique need adjustment to better tell your story?

Check Out Composition Masters

For a variety of strong compositions, check out the paintings by these fabulous artists: Jan Vermeer, Andrew Wyeth, Franz Kline, Juan Gris, Giotto and Hiroshige. Each of these artists approaches composition in ways unique to their time and culture.

COMPOSITION GAMES

DOUBLE TAKE

OBJECT To complete two or more paintings.

PURPOSE To practice seeing with fresh eyes.

PLAY Gather two or more people. Have each person start a small painting. After fifteen minutes, switch paintings and continue painting another's painting while someone else paints yours. After another fifteen minutes, switch again. Continue until your paintings are finished (or until one of you cries "Uncle!"). More important than coming up with two masterpieces is the lesson learned by having to see the painting in front of you with fresh eyes.

Zoom In to See Technique

Get close to your painting to examine small sections and evaluate brushstrokes. Was the paint applied with confidence and knowledge of the medium? Do the strokes convey what you want them to convey? When you paint, your brushstrokes are the fingerprints that reveal your inner motives. If you're not enjoying yourself, it will show in the way you handle a brush. Strokes reveal the artist's inner state, whether he is sensitive or hesitant, expressive or sloppy, detailed or obsessively compulsive. Good technique takes practice and attentiveness to the quality of strokes, paint-mixing methods and choice of brushes.

The Spatial Worlds

In the universe of painting, there are three spatial worlds: deep, shallow and flat. It's important to pay attention to whatever world you are painting in at any given moment.

The Deep World

This world contains vast distances and applies the techniques of *atmospheric perspective*, where you lessen the color intensity, size and texture details of objects as they recede. The deep world is a candy store of light qualities as you manipulate the light to demonstrate atmospheric perspective. You learned some basics for creating depth on pages 22–23. The deep world allows you to explore perspective, foreground, middle ground and background. For some exquisite examples, look online or go to the library and look at the landscapes of Albert Bierstadt and the other Hudson River School painters.

The Shallow World

The shallow world is representational, confined and not terribly dependent on depth. Examples are still lifes and room interiors. The shallow world takes a close look at things in confined spaces, so you have to pay extra attention to details, light sources and representational accuracy. Check out the interiors of Vermeer and the still lifes by William Harnett.

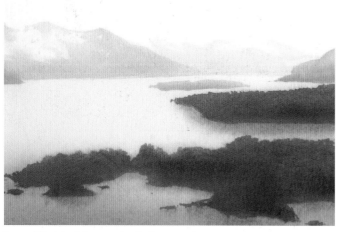

Deep World of Atmospheric Perspective
In the deep world, objects in the foreground become larger, and the atmosphere becomes muted and light toward the background.

The Flat World

The flat world consists primarily of pattern, shape and color without concern for depth or realism. Lacking depth, a successful flat world painting energizes patterns, shapes, lines, colors and textures, then arranges them into a coherent and unified whole in a way that stirs emotion within the viewer. Much of modern art is based on the flat world. See the works of Matisse, Gris and Chagall. There is little or no spatial depth in this world but plenty of energy.

Merge the Worlds Carefully

When deep, shallow and flat meet in a single painting the result is either a catastrophe or a happy dance. The key is to keep them clearly separate within the painting. Wonderful results may occur.

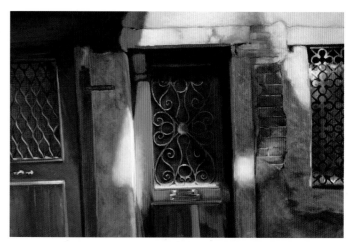

Flat World for Texture, Pattern, Color and Shape
Old walls and doors can be beautiful. Some modern art uses this flattened method to downplay the subject matter in order to heighten our attention on the aesthetic merits of shapes, colors, and textures.

Try This

With your camera or sketchbook, seek out and sketch examples of each of the compositional spaces: deep, shallow and flat. Then sketch or paint scenes that merge the worlds: flat with deep, flat with shallow, and shallow with deep.

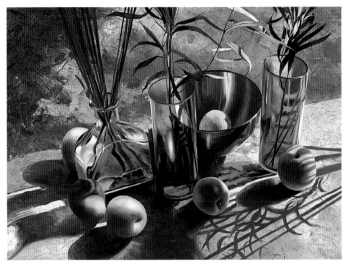

Shallow World Studies the Details

This world invites viewers to scrutinize the details of the objects and their relationships carefully. Realism rules here.

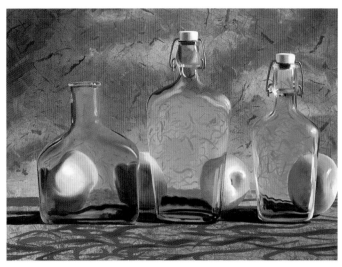

Flat and Shallow

This painting works because the still life objects are painted within a confined space and viewed straight on so there's no perspective. At the same time, the wall behind also flattens the painting. Had the background texture been painted with bright hard-edged colors it would have competed visually with the colors and edges of the subject.

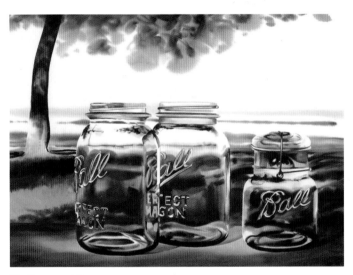

Shallow and Deep

These jars are contained within a shallow, intimate foreground. Beyond them looms a distant horizon. The deep and shallow worlds have been kept apart. The blurred objects in the background help to create depth, while the crisp tight lines on the jars create sharp focus in the foreground. Had the background details been as vivid as the details in the jars, the two worlds would have visually collided and become discordant.

Flat and Deep

Foreground grasses are flat to the picture plane but misty trees beyond suggest deep space. Keeping those two sections distinctively apart is what makes them work in one painting. Imagine if we had painted the foreground grasses like the background, all soft and fuzzy. There would be nothing to distinguish them as a flat foreground subject and the painting would have been visually ambiguous.

Pro Paint-by-Number With Oil

With watercolors, there are several basic techniques and rules to learn and practice. Oil painting is less easy to define. The best way to learn oil painting is to jump in with both feet and see what happens. Play with the paint: smear it around, scrape it, brush it and mix it. See what various color combinations do.

What is Pro Paint-by-Number?

Remember paint-by-numbers? The pros have a good laugh about this approach, but ironically many of them use a similar process. Seasoned artists use several oil painting techniques. One of them is very similar to the paint-by-number method.

1. Pros draw their own compositional outlines either literally on the canvas or board or in their imaginations.
2. Pros select and mix their own colors.
3. Rather than ending up with hard edges between the shapes, they blend the edges together smoothly or give the edges some quality of character.

Materials

Surface
12" X 16" (30cm X 41cm) canvas board

Brushes
⅜-inch (10mm) and ¼-inch (6mm) Filberts

Paints
Burnt Sienna, Cadmium Orange, Cadmium Red, Cadmium Yellow Medium, Ivory Black, Titanium White

Reference Photo
Examine your reference photo or sketches carefully before you begin a painting. Consider each area of the image and ask yourself how you will paint it and what technique you will use. Make mental notes of any areas that may represent special challenges.

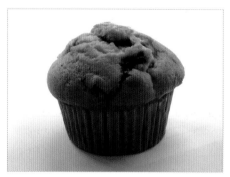

Color Tip

To make light background areas seem brighter and warmer, add a hint of yellow.

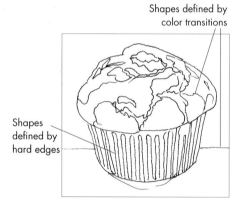

Shapes defined by color transitions

Shapes defined by hard edges

1 | Divide the Picture Into Shapes

Study the image, then divide it (either literally by drawing it or by taking mental notes) into shapes that are defined by hard edges and where transitions of color are evident.

2 | Fill Shapes With Color

Play with mixtures of the colors. Fill in the shapes with mixtures and combinations to match your subject.

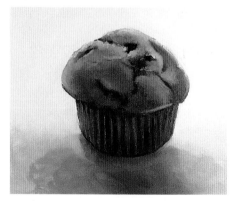

3 | Blend the Shapes Together

Blend the edges to create softer transitions. Simulate the texture of a muffin (or whatever you're painting) with your brushstrokes. Study your reference again and add dashes of color here and there. To blend the foreground shadows with the background, dip the flat side of your brush into the paint with a circular motion, as if polishing.

Color Patch Technique

In the previous demonstration you created an object-oriented, or shallow painting. Now you'll do a deep painting using the color patch technique to create atmospheric perspective (see sidebar). This technique energizes the painting with vibrant patches of colors. Just apply each dab of paint separately without mixing or blending it with any adjacent colors.

Materials

Surface
Canvas board (any size)

Brushes
⅜-inch (10mm) flat

Paints
Cadmium Orange, Cadmium Yellow Medium, Dioxazine Purple, Ivory Black, Phthalo Green (Yellow Shade), Ultramarine Blue, Titanium White

Other
Mixing container
Odorless mineral spirits
Paper palette

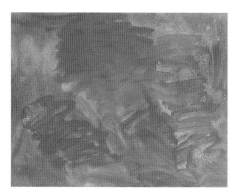

1 Prepare the Underpainting
Paint a canvas board orange. Use a touch of odorless mineral spirits in your mixture so the paint has a mottled quality. Let it dry before proceeding.

2 Paint the Landscape Greens
Add some warm greens and shadowy dark colors. The exact color is not as important as using a variety of green tones. Let the orange underpainting show. Don't use any mediums or thinning agents. Just squeeze the paint onto the palette, mix it with other colors if you want, then apply it directly to the canvas board.

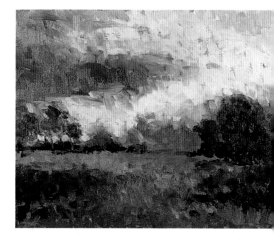

Object and Atmosphere

All representational painting is based upon two fundamental approaches (or a combination of them), *object-oriented* painting and *atmospheric* painting. An object-oriented painting draws attention to an object or objects, such as the muffin on page 36. The atmospheric approach provides no one object to look at, rather it presents vistas, deep space and lots of air. It also has a sense of place. Landscape painters often use the atmospheric approach.

A painting may use both approaches but few paintings are ever fully object-oriented and atmospheric at the same time.

3 Paint the Sky
Add whatever colors you might see in a sky. Keep the clouds more or less horizontal and use a combination of light, midrange and dark tones.

4 Finish the Painting
Add trees to create scale and distance. The hard edges of the patches of paint and the undercoat of orange that show through create a shimmering effect.

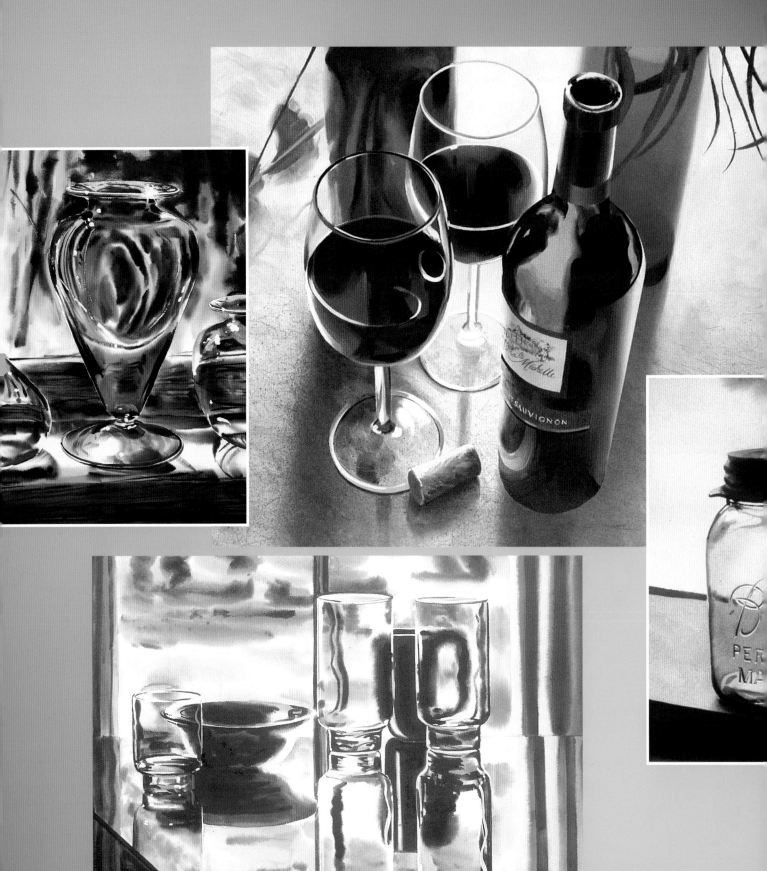

2

Transparency

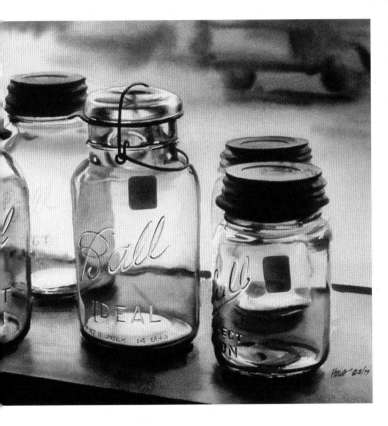

The nature of clarity and transparency has always fascinated artists—a clear night sky, clear waters, a pure diamond, a crystal chandelier. A poet once wrote of a world with an ocean and atmosphere so clear that you could look up from the deepest depths of the ocean and see every star in the night sky perfectly—what a wonderful thought. Within ourselves, we prefer being clear-headed, expressing ourselves clearly and following clear instructions. Often people look at the painting of canning jars to the immediate left and ask how I made them look so clear. "You can see right through them," they say. My standard tongue-in-check reply is, "I just get out the tube of Clear and slap it on."

Seriously, painting clear surfaces like glass is like painting something that isn't there at all. When you look through a window you don't actually see the window. It's not actually possible to paint clear materials like glass because they can't be seen. You see transparent materials only when you detect the surface edges, reflections, tints, flaws and markings. These are the things that inform you that they're there. Glass becomes visible only when you see what it is not. This is the secret to painting anything clear. You look for what is visible through it, in it or on it.

Transparency Simplified

This diagram shows the transition from opaque flat shapes to transparent cylinders. There are five basic rules for painting transparency:

- A transparent object is invisible; therefore, objects behind the transparent object appear within its contour.
- Transparent objects often have waves and distortions. So paint the background that is visible inside the contour as if it is wavy or distorted.

- If the transparent object is tinted a color, paint the background visible within the contour of the transparent object with a tint of that color.
- The outline of a transparent object is made visible by the light reflections and shadows that surround it. In the case of a window, the window sashes help define it.
- Paint surface lettering or markings on the transparent object as if they are a part of background visible within the contour.

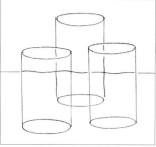

Three Opaque Cylinders

Three Opaque Shapes

Three Transparent Cylinders
A wire-frame drawing alone makes the cylinders appear clear.

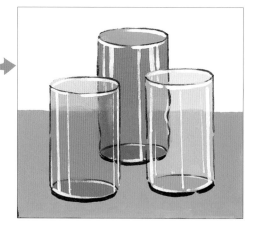

Three Transparent Cylinders on a Tabletop
The wavy distortions of the cylinders in back and the edge of the tabletop as it appears inside the cylinders make the glass look flawed and therefore more believable as glass.

Three Transparent Shapes
The areas that overlap are a combination of the overlapping colors.

Three Transparent Shapes on a Tabletop
The back edge of the table, as seen through the transparent squares, makes the transparent shapes seem even more transparent.

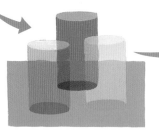

Three Transparent Cylinders on a Tabletop With Color
Distorting the contours behind the glass will make the glass seem more realistic.

Three Transparent Cylinders on a Tabletop With Color and Highlights
The highlights define the contours and surfaces of the cylinders and make them appear shiny and glasslike.

How to Convey Transparency

You can apply the rules of transparency (see page 40) to any transparent object you paint. Developing a good grasp of this concept will enable you, with a little practice, to add transparency wherever you want it. Apply what you've learned so far for this lemon and bottle exercise. To make it simple, keep the background behind the lemon and bottle white.

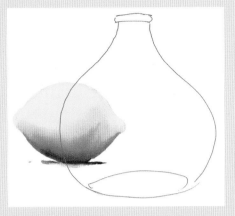

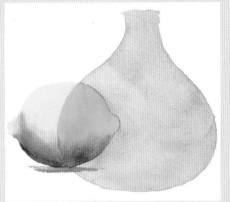

Create Basic Transparency
Paint a lemon and add brown-gray at the bottom for shadowing. Next, draw the shape of a bottle overlapping the lemon. The bottle already looks transparent and you haven't done anything fancy yet. The bottle's contour alone suggests clear glass.

Paint Transparency With Shapes and Knocking Edges
1 Draw the contour of a bottle and lemon as before.
2 Paint the part of the lemon that is outside the bottle shape (left).
3 Paint the greenish lemon inside the bottle shape and let dry.
4 Paint the bottle shape blue and make the blue butt the lemon, but not overlap it. The lemon shape inside the bottle is green because when yellow (the lemon) is mixed with blue (the bottle) it makes green (the lemon behind the bottle).

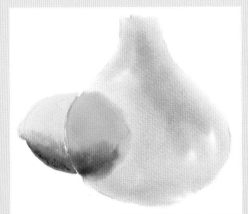

Paint Transparent Glass
1 Paint the left side of the lemon and add brown-gray at the bottom for shadowing and let dry.
2 Wet the inside of the bottle shape including the lemon inside the bottle and let it dry to a satin sheen. Apply a light tone of blue-green where the lemon shape is, then immediately apply a light blue color in the surrounding bottle interior—but don't touch or overlap the blue-green lemon area with the blue! Instead, let the blue of the bottle and green of the lemon bleed together slowly and naturally. Let it dry.
3 Using a smaller brush, add highlights of white and shadows of blue and black around the contour of the bottle. The highlights and shadows give the bottle form.

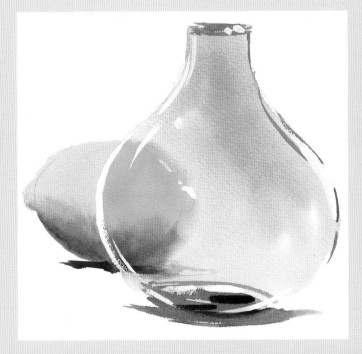

Paint Transparent Glass

Your paintings do not have to be complex to be dramatic. Though this painting will be more complex than the lemon and bottle exercise on the previous page, it still uses simple shapes. The photo is comprised of only two color sets: The apricots are orange and everything else is shades of blue. The background is slightly more detailed, and it's visible within the bottle.

The natural light makes most of the shadows' edges very soft. The painting style will be loose and sketchy. You'll use the basic transparency techniques, a simple palette and loose brush to paint this soft-edged, transparent subject.

Materials

Surface
Arches 140-lb (300gsm) cold-pressed paper, full sheet

Brushes
Chip or hake brush for washes, 2½-inch (63mm), 1-inch (25mm) and ¼-inch (6mm) flats

Paints
Alizarin Crimson, Burnt Sienna, Cadmium Orange, Payne's Gray, Ultramarine (Green Shade), Winsor Green (Yellow Shade)

Other
Masking fluid
Paper towels
White gouache

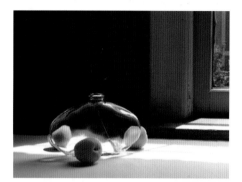

Reference Photo
Remember, your photos don't have to be perfect to work as excellent references. Look for interesting colors and compositions.

1 | Create the Drawing and Apply the Masking

Keep the drawing sketchy so you can have the flexibility to move things around. I moved the middle apricot to the left because it seemed too centered in the reference photo. Mask the inside edge of the bottle and the apricots so you can play fast and loose with the paint around them.

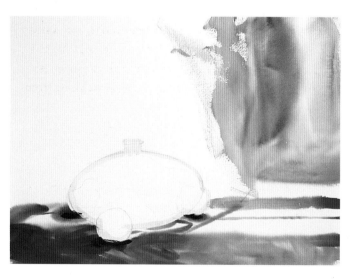

2 | Begin the Undertones

Erase any grid lines or other pencil marks you don't want in your finished painting. Make sure your brushes and paints are ready to go; drying water waits for no one.

Tone down the light shining on the windowsill. Paint the area surrounding the apricots and bottle in a wet-to-dry method first because these shapes are large and generalized.

Wet the entire area surrounding the bottle. Using a 1-inch (25mm) flat, apply the lightest tones of Ultramarine (Green Shade) with touches of Payne's Gray where the blue is darkest. Get as far you can before the paint dries. Let this layer dry completely before applying the next, darker layer of blues. Let your brushstrokes show in the foreground shadows so the painting will have a gestural quality.

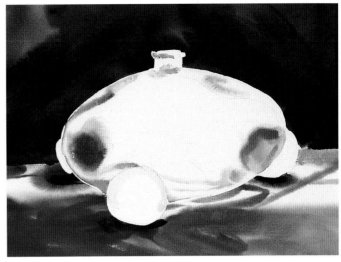

3 | Complete the Background

Make sure you don't lose the white highlights; they are critical elements and necessary for the success of the finished piece. The white will provide strong highlights that will make your painting really snap.

With a chip or hake brush, wet the area surrounding the apricots and bottles except for the lower tabletop. Let it dry to a semigloss sheen (see page 15). Apply increasingly darker tones of Ultramarine (Green Shade) with a 1-inch (25mm) flat. As the blues become darker, add increasing amounts of Payne's Gray until the area surrounding the bottle is very dark. Do not use a straightedge for your lines and edges; looser, spontaneous lines express confidence and contrast nicely with the tighter edges within the apricot and bottle area. Leave the upper left corner somewhat unpainted to create a light effect. Remove the masking as soon as the paint dries.

4 | Paint the Interior of the Bottle Shape

The edges within the bottle's interior all have about a ¼" (6mm) dispersal rate. The large dark shadow is an anti-water shape (page 21). Move slowly to capture the subtleties. You want your edges to disperse just a little. Mask the foreground apricot and let it dry. Wet the inside shape of the bottle and let it dry to a satin sheen. Be careful not to touch the adjoining dark blue background above the bottle because it will flood into the bottle shape. Keep your wetted area about ¼-inch (6mm) away from the top edge of the bottle. Apply Winsor Green (Yellow Shade) tones around the edges of the glass to get the mint green undertone. Apply the Cadmium Orange colors of the apricots within the bottle shape. To capture the form and volume of the apricots, check the reference photo. Add Alizarin Crimson then Burnt Sienna, and let dry completely.

5 | Paint the Final Layer of the Bottle's Interior

Wet the inside shape of the bottle, excluding the apricots, and let it dry to a semigloss sheen. Add lighter tones of a combination of Ultramarine (Green Shade) and Payne's Gray. Increase the shades and saturation as you progress into the darker areas. Let it dry and remove masking from the foreground apricot.

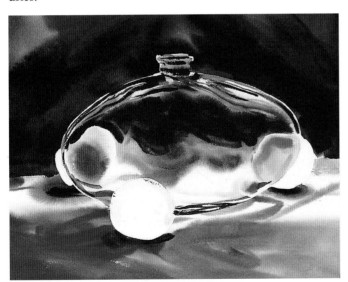

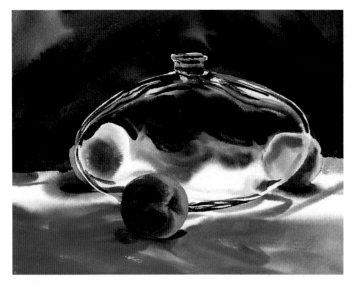

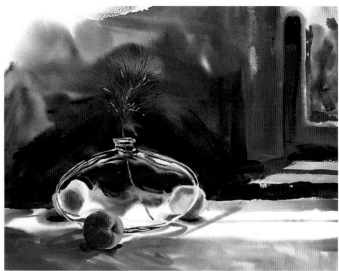

6 Finish the Apricots

Notice the light on the right edge of the apricot at the right. The foreground apricot is in shadow so even its lightest tones will be somewhat dark. The apricots must appear soft and fleshy.

Flood the apricot shapes with water and let them dry to a semigloss sheen. Apply the lightest tones first with a light mixture of Cadmium Orange and Alizarin Crimson. Use Burnt Sienna and a touch of Payne's Gray for the darker tones.

7 Paint a Sprig

While it doesn't show up well in the reference photo, imagine a wispy sprig emerging from the bottle's mouth. It looks black, with a midrange green and light green needles that catch hints of the light. Use the side of your ¼-inch (6mm) flat. Apply colors in reverse this time (from dark to light) and use white gouache.

With straight Payne's Gray paint delicate strokes as the sprig fans out. Start at the opening of the bottle and grow your strokes upward and outward. Make a green mixture of Winsor Green (Yellow Shade), a touch of Cadmium Orange and white gouache to create a midrange green, then apply it in the manner described above. Starting from the bottle's mouth, grow the green portions upward and outward. Add Winsor Green (Yellow Shade) with white gouache to make the light green value you'll use for the highlight color. Add delicate dashes here and there to simulate the effect light has on the sprig, but don't overdo it. Paint the stem inside the bottle in the same manner.

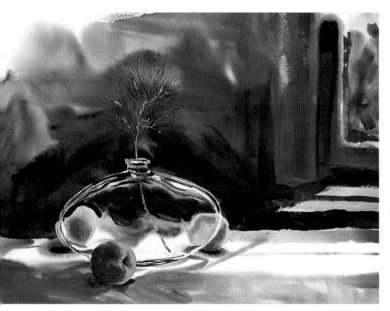

8 Add the Final Touches

The apricots are a little too "hot." The colors are a little too harsh. Flood the apricot shapes inside the bottle and agitate the pigment with a brush, loosening it and spreading it around. This will dull back and soften the color of the apricots a little.

Caution

Painting the sprig could be catastrophic if it's not done with sensitivity. You don't want it to look like a tree stump or cat claw marks. Practice on a scrap piece of paper first.

Paint Highlights On Clear Plastic

Previously you've learned the oil Pro Paint-By-Number technique and the Color Patch technique. Here you will learn the Basic Medium Painting technique. Now you get to apply what you've learned about transparency to the clear plastic around multicolored candy.

Remember, solvents weaken the paint and oil mediums strengthen it (see page 13). Oil mediums strengthen paint because they add binder, and thus flexibility, into the paint's structure. Mediums also allow you to thin the paint (by adding more medium) and to apply it in semitransparent layers so the colors underneath show through. This is called *glazing*.

In every step, and with every brushload of paint, add some medium and a touch of odorless mineral spirits or turpentine to make the paint transparent and slippery. Or, make a mixture of 90 percent medium and 10 percent odorless mineral spirits and stir well. Dip your brush first into this mixture, then into your paint.

Materials

Surface
12" x 16" (30cm x 41cm) primed canvas board

Brushes
⅜-inch (10mm) bright, ¼-inch (6mm) flat, No. 2 round

Paints
Black, Cadmium Orange Deep, Cadmium Yellow Medium, Manganese Violet, Permanent Green Light, Quinacridone Magenta, Titanium White, Ultramarine Blue

Other
Medium
Mixing containers
Odorless mineral spirits
One or two paper palettes

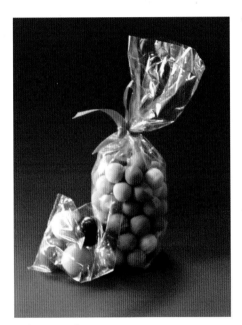

Reference Photo
The forms and shapes of candy and pastry are perfect for studying volumes and colors and for developing brush dexterity. Plus, if you go professional and decide to taste this subject matter (strictly in the name of art, of course) to better understand your subject, you may be able to deduct the cost of these "artist materials" from your taxes. Something to think about while licking your fingers.

Begin With a Sketch
Remember, you're only trying to capture the shapes of the subject.

1 Prepare the Underpainting
Coat your canvas board with Cadmium Orange Deep. The purpose of the underpainting is to add extra warmth and more complexity of color to your finished painting where the underpainting shows through.

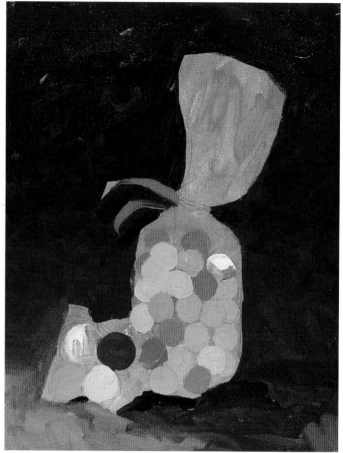

2 | Transfer the Drawing and Begin the Background

Transfer the image onto the canvas board and paint the background using a ⅜-inch (10mm) bright and Quinacridone Magenta and Ultramarine Blue. Add a touch of Titanium White for the lighter areas of the foreground. Use Ultramarine Blue instead of black to add shadows. Be sure to let hints of the orange underpainting show through.

3 | Paint the Candy

Take note of the value range of the chocolate balls' highlights, midtones and shadows.

Use a ⅜-inch (10mm) bright to paint those midtones first. You'll add the highlights and shadows later. Use the following colors: Green balls—Permanent Green Light and Titanium White; Pink balls—Quinacridone Magenta and Titanium White; Purple balls—Manganese Violet, Ultramarine Blue and Titanium White; Yellow ball—Cadmium Yellow Medium and Titanium White.

Caution

If your painting becomes so gooey that your brushstrokes become ineffective, let the painting dry for a day or two, then come back to it. You want the white highlights to have sharp, hard edges.

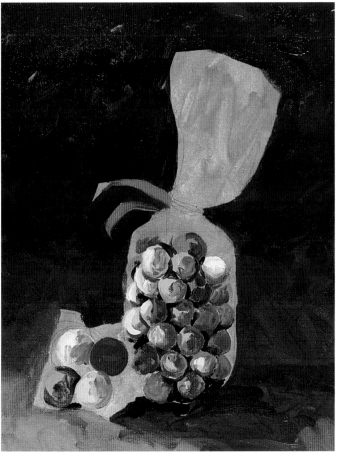

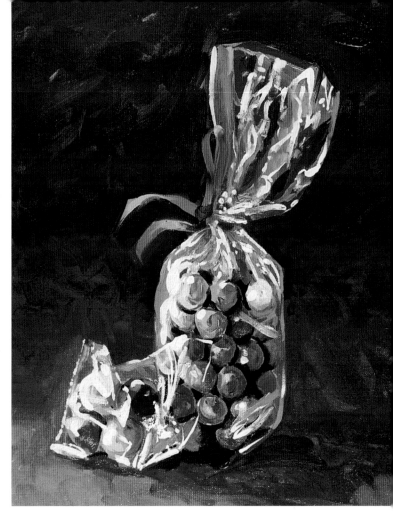

4 Add Highlights and Shadows to the Candy

Most shadows contain a variety of colors, so add red into the shadows of blue, green into the shadows of yellow and so on. Experiment. Add the highlights and shadows with a small round. Keep it loose. You're not after perfectly smooth spheres.

5 Paint the Plastic to Finish

The values in areas where you can see the background color through the wrapper are slightly lighter than the background colors. The wrinkles in the clear wrapper contain sharp white highlights and slightly darker or muted highlights.

With tones slightly lighter than the background, fill in the area between the chocolate balls and the wrapper's contour using a ¼-inch (6mm) flat and Ultramarine Blue with a touch of Ivory Black and Titanium White. Without overanalyzing the details of the plastic (let the brush do the thinking), begin putting in the slightly darker shades of highlights using the same colors. Then put in the sharp white highlights with Titanium White. Add the orange ribbon using the no. 2 round and a mixture of Cadmium Orange Deep and Cadmium Yellow Medium.

Stand back (zoom out) to study your creation. Zoom back in and add the finishing touches. Add some dashes of orange here and there along with a little black in the shadows—presto! You're finished.

Paint Water and Light Distortions

Now you will learn how to paint shiny, sunlit, transparent water as it interacts with light. The figure is partially in the water and partially out, which provides a convenient contrast between the distorted and undistorted parts of the figure.

Water is transparent just like the glass and plastic you painted in previous exercises. The only difference is that water is far more distorted because of its undulating action. Look at the reference image as a group of interlocking, albeit wiggly, puzzle parts. The sharp sparkles of reflected sunlight are what give the water its slick glossy look. Here the edges are not as conveniently defined as the glass bottle you painted earlier.

Materials

Surface
140-lb. (300gsm) cold-pressed paper, full sheet

Brushes
Chip brush, or hake, for large washes; 2½-inch (63mm), 1-inch (25mm) and ¼-inch (6mm) flats, ¼-inch (6mm) flat bristle, ¼-inch (6mm) bright, ¾-inch (19mm) and ½-inch (12mm) Sumi-e brushes, small round masking brush

Paints
Alizarin Crimson, Burnt Sienna, Cadmium Orange, Cobalt Turquoise, Payne's Gray, Ultramarine (Green Shade), Winsor Yellow Deep

Other
Masking fluid
White gouache

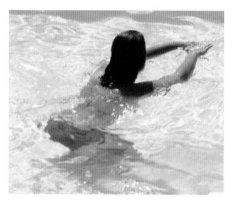

Reference Photo
Even though this photo was shot from a distance and its quality is not perfect, there's enough visual information to paint the effect of water when its surface is wavy.

Make a Rough Drawing
Let your brush create the water distortions when you get to the point of defining the waves in the painting. Until then, simply sketch the figure's contour. Then, with a small round masking brush, apply liquid mask where the sunlight sparkles should be.

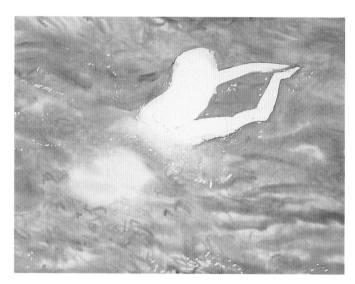

1 | Paint the First Undertones

Pay attention to the red swimsuit and the shadows in the swimmer's back and leg areas that are underwater. Render the water expressively with a loose brush.

Wet the entire paper except where her upper body rises above water, and let it dry to a semigloss sheen (page 15). Apply a light wash of pre-mixed Winsor Yellow and Cobalt Turquoise for a light green color. Let the wash remain irregular and somewhat splotchy. Allow it to dry.

Rewet the entire paper and let it dry as before. With a ¼-inch (6mm) bright, dab in Cobalt Turquoise in a small circular motion. If the wet areas of paper dry before you get to them, simply apply more water in those areas with a chip brush or hake.

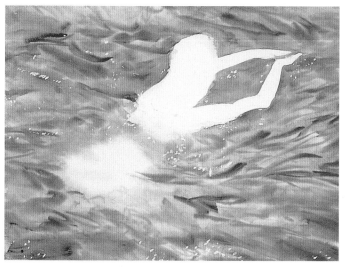

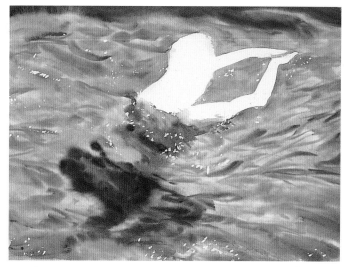

2 | Paint the Overall Turquoise Layer and Waves

Flood the paper with water except where the swimmer is above the waterline. Use the 1-inch (25mm) flat to create the ribbon effect of waves as you apply Cobalt Turquoise irregularly, simulating the midtones and dark tones in the water. Look carefully at the waves, then let your brush do the rest. The swimmer's lower back has less blue, so make sure the wash doesn't bleed into that area.

Applying the turquoise in two layers increases the color and value complexity. The first turquoise layer is marbled; the second layer has wavy brushstrokes. Together the layers create the swimming pool look.

3 | Paint the Figure Below Water

The brown-beige hue of the flesh tones when seen through the blue hue of the water appears slightly greenish.

Use a ¼-inch (6mm) flat to flood that area. Watch the bleeding as you apply the lightest flesh tones with a light mixture of Cadmium Orange, Burnt Sienna and a touch of Cobalt Turquoise using the same brush. Then add the darker flesh tones with the same colors but with more saturation (see page 17) and more Cobalt Turquoise. For the red swimsuit use Alizarin Crimson and a dash of Cobalt Turquoise. Create the swimsuit's darker tones and shadows with saturated amounts of the same colors.

Try It

The part of the figure above water could have been masked, but I chose not to because it wasn't essential to hold the whites there. Masking the sparkles of light with little dots looks better than scratchy marks or lines would.

Always remove masking fluid as soon as possible. It gets increasingly difficult to remove the longer it remains on the painting surface.

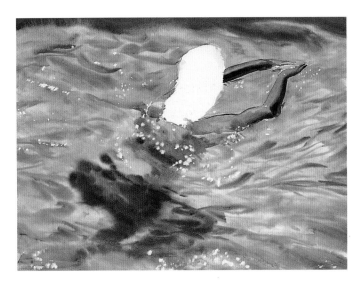

4 Paint the Arms

Using a ½-inch (12mm) Sumi-e, apply water on the arms and shoulders. Make a light mixture of Burnt Sienna, Winsor Yellow Deep and a touch of Ultramarine (Green Shade) and apply a light wash. When that has dried to a satin sheen, apply the darker tones using the same colors only more saturated. Add the shadows last using the same colors, except heavier on the Ultramarine (Green Shade).

Caution

Be careful when painting the edges where the water and arms meet. They must be sharp to maintain correct anatomical appearance and distinction from the surrounding water.

Caution

Because the hair appears to be a solid black blob shape, you'll intentionally bring values into this area to create some sense of texture and to avoid a flat, stenciled shape.

Whenever you have a solid colored hard-edged shape in a painting, the shape will tend to move visually from its place in the atmospheric world inside the painting to the surface, making it seem flat.

If you want to avoid this, add modulations of tones within the shape to soften its edges and keep it anchored inside the picture's atmospheric world.

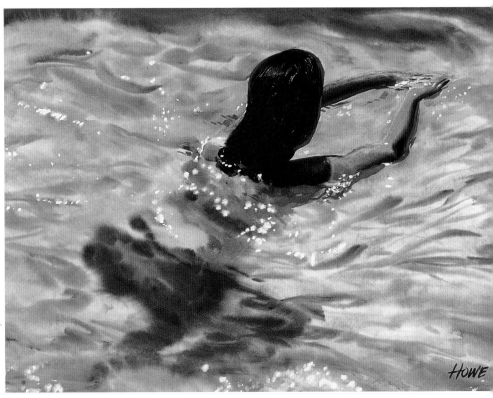

HOWE

5 Paint the Hair to Finish

Since the hair is very dark, the highlights will be fairly dark, too. Use Burnt Sienna with a dash of Payne's Gray for them. Using a ½-inch (12mm) Sumi-e, apply the darker hair strands in the highlight areas and the darkest parts of the hair with Payne's Gray, but make sure there are some shifts in value. Randomly apply Cobalt Turquoise with a touch of white gouache along the contour of the hair. This will soften the transition between the hair and the surrounding water.

White Creates Shimmering Light

It is no wonder people respond to paintings of jars, vases and bottles. In this lesson you will gain a deeper understanding of painting transparency. As you've learned already, to paint a transparent (invisible) surface you are really painting what's visible through it and the colors, reflections and markings on its surface and contour.

In this picture the background is very busy, bristling with colors and textures. This will afford you the challenge of capturing the wild distortions visible within the vase shapes, which also communicate the vases' volume. In addition, you will take a step forward with your watercolor painting technique as you learn to control the subtle degree of pigment bleeding that this painting will require.

Materials

Surface
140-lb (300gsm) cold-pressed paper, stretched, full sheet

Brushes
3-inch (76mm) chip brush, 1-inch (25mm) and ¼-inch (6mm) flats

Paints
Burnt Sienna, Cadmium Orange, Payne's Gray, Raw Umber, Ultramarine (Green Shade), Winsor Green (Blue Shade), Winsor Violet, Winsor Yellow

Other
Masking fluid
White gouache

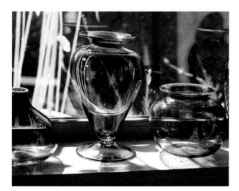

Reference Photo

Caution

Before laying a new wash over an existing wash, make sure the existing wash is thoroughly dry. If the existing wash isn't completely dry, the existing pigment will loosen and lift, blending with the new wash of color.

1 | Create a Grid Drawing

Draw a grid on your photo, and a corresponding grid on your watercolor paper (see page 26). Pay particular attention to the symmetry of the center vase and the elliptical shapes of its mouth and base.

2 | Apply Masking

You want to create the illusion that the background and windowsill are behind and under the clear glass vases. Masking helps achieve this because the washes of color will appear to go behind and under the vases.

3 | Create the Undertones

Only the outline of the vases and the sill of the window have hard edges. Most of the other shapes and colors are softer. Lay down only the lighter tones in the background with the 1-inch (25mm) flat. Because the sill is basically only two colors (brown with darker brown grain) and visually uncomplicated, paint it in one wet-to-dry wash. For the browns use Burnt Sienna; for the dark brown grain use Raw Umber with a touch of Payne's Gray.

Flood the upper background with water and let dry to a satin sheen. With the 1-inch (25mm) flat, apply the colors playfully, following the highlights in the reference photo. Watercolors look a lot lighter when dry than when wet, so saturate your brush with pigment.

When the paper has dried to a semigloss sheen, apply Cadmium Orange and random dabs of Burnt Sienna to the windowsill to give it a rich mottled quality. Create shadows in the lower part of the wash with Winsor Violet and Ultramarine (Green Shade). When the water on the paper has a satin-eggshell sheen, add the gently curving line of the wood grain with the edge of the ¼-inch (6mm) flat using Ultramarine (Green Shade) and a little Burnt Sienna.

4 | Add the Final Background Layer

Study the reference photo. Notice how dark the upper right of the background is and how light the lower left is. The shadow areas require a lot of paint so make sure you have a good supply ready to go.

Lay a saturated wash over the undertone wash with the chip brush. In a playful manner, apply the final layer of paint. It is more important to be true to the value ranges in the reference photo than it is to paint the exact shapes and colors you see in the photo. Mix Winsor Green and Payne's Gray to apply the dark greens when the paper has dried to a semigloss. Apply the left side details with the same colors when the paper has dried to a satin sheen. After the paint is thoroughly dry, remove the liquid mask.

Caution

Be alert to the paper wetness. You'll have to paint the grain in the sill when the paper is a lot dryer than when the brown of the sill is applied.

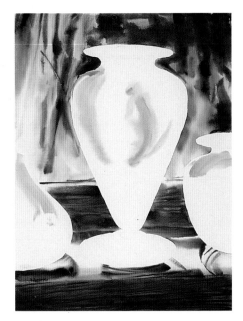

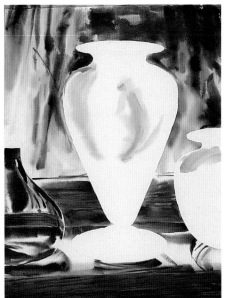

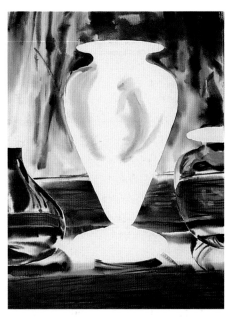

5 | Add Vase Interior Undertones

Flood the vase interiors with the chip brush. When the paper has dried to a satin sheen, use the 1-inch (25mm) flat to apply Winsor Yellow and Winsor Green (Blue Shade).

Caution

When flooding the interiors of the vases, remember there is no protective masking. Avoid slopping any water beyond the edges. Wherever water goes, paint will soon follow.

6 | Paint the Left Vase

Finish the small vases first in case there are any problems. That way, you'll be able to solve them in those less noticeable areas. Complete this step as one wet-to-dry layer. Keep the painting loose within the confines of the vase.

Saturate the interior shape with water. Let it dry to a satin sheen. With the ¼-inch (6mm) flat lay down light tints (see page 17) of Winsor Violet and the narrow violet stripes. Using the 1-inch (25mm) flat, apply a saturated Cadmium Orange to create the reflective wood grain. Let the entire vase dry to a satin sheen. With the 1-inch (25mm) flat, lay on super-heavy amounts of saturated Winsor Violet to punctuate the shadows. When the water has dried to an eggshell sheen, use the edge of the ¼-inch (6mm) flat to add the wood grain with a mixture of Burnt Sienna and Winsor Violet.

7 | Begin the Small Vase at Right

The white areas that will represent sparkles of light in the end are small and will require you to use a satin-eggshell paper wetness; otherwise they will be overcome by washes of other colors. Saturate the interior of the vase at right with the 1-inch (25mm) flat and let it dry to a satin sheen. In the same manner you used for the left vase, apply colors starting with the lightest tints of Winsor Violet. When the paper dries to an eggshell sheen, add darker shades of Winsor Violet. Add Burnt Sienna and Winsor Violet to the Cadmium Orange to make the reflected sill appear in shadow.

(Note: Sometimes things don't go as planned. In my execution of this step I failed to maintain white highlights on the upper part of the vase, as I had so wisely instructed. We'll come back later to add dabs of white gouache to those areas.)

Caution

Make sure the spreading color does not overcome the white of the paper. The white will create the shimmering light when the painting is finished so it must have a strong presence.

8 | Paint the Center Vase

The interior shape of the center vase has darks that are almost black and light areas that are white. The dark areas are not clearly delineated, but the narrow grassy shapes are. Pay special attention to the small white highlights and the thin grass reflected on the left. Retain as much of the white areas as possible.

Flood the entire interior area with the chip brush and let it dry to a satin sheen. Using the 1-inch (25mm) flat, lay in the light Winsor Violet tints, adding dashes of Cadmium Orange to give the color more dimension. Add heavy amounts of Winsor Violet and Payne's Gray to create the darkest areas. Make sure the dark violet areas are as dark as possible—really load on the paint. When the paper is eggshell dry, put in the narrow violet lines between the reflected grasses.

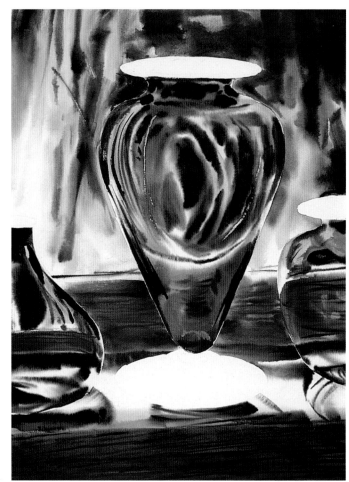

9 | Paint the Rims, Mouths and Base

The green rims, sharp and framed in white, are smaller areas to paint so use the ¼-inch (6mm) flat. Retain the whites, darks and the emerald green color on the rims. To paint these narrow elliptic shapes, position yourself so your arm and hand holding the brush are comfortable and in a natural position to make curved lines. Practice on a separate piece of paper first.

Paint the emerald green rims wet-on-dry using Winsor Green and Winsor Violet. After the rims dry, create a wet-on-wet shape for the interior of the base of the center vase. Make sure you retain the sliver of white adjacent to the rims. Add light tones of violet where you see them; when the paper is eggshell dry, add the darkest violets.

10 Finish the Vase

Use thick dabs of white gouache to make highlights. Notice that the edges of the vases do not look masked. Compared to the other elements of the painting, the vase contours are the sharpest and hardest edges. But they don't have that masking cookie-cutter look because of the irregularity and complexity of the colors you've applied near to and touching the contour's edges.

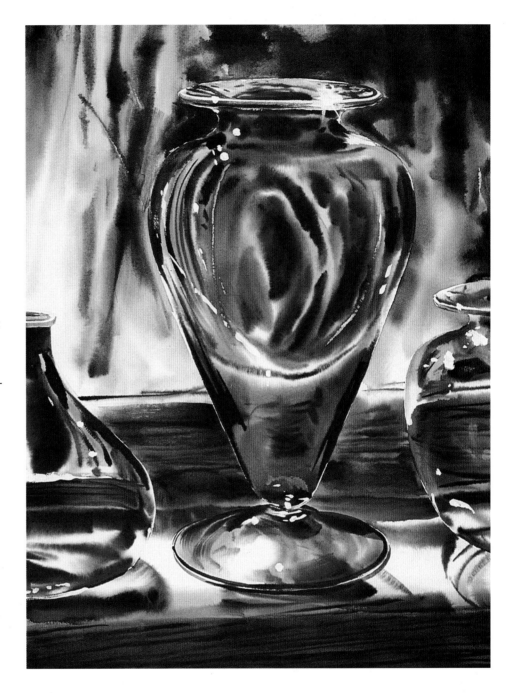

3

Translucence

The handiwork of mystery, translucence diffuses, obscures and softens any subject it embraces. With transparency you get it all; you see everything in perfect fidelity. With semi-transparency you see everything in diffused, semiperfect fidelity. But with translucence you get light without any defining details of the subject it embraces. That's its beauty.

In this chapter you will explore the edgeless, soft world of translucence. Prepare to gain proficiency in painting this mysterious quality of light.

Paint Semitransparency

Semitransparency describes when you can see an object (like a banana) behind a semitransparent material. It is obscured or diffused to some degree, but is still identifiable. Translucent light occurs when light shines through an opaque object. The light is diffused so much that any object behind it is obscured; only the light comes through.

In this lesson you will explore the diffused softness that semitransparency offers while you gain greater control of the wet-on-wet painting technique that will ultimately help you paint translucent light.

1 Draw and Paint a Banana
Draw a banana with a square in front of it. Then paint the parts of the banana that extend beyond the square.

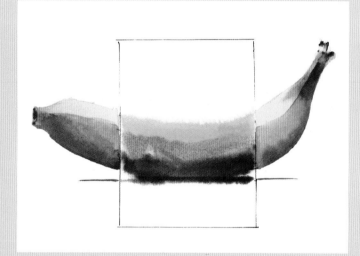

2 Paint the Banana Inside the Square
Paint the part of the banana inside the square in a wet-on-wet technique, letting edges diffuse and adding shades of green into your paint mixture. Let it dry.

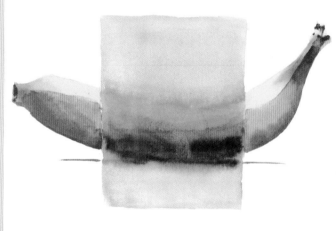

3 Overpaint the Square
Overpaint a tint of blue, filling the square. The banana now appears to be behind a blue semitransparent square.

Layer to Create Translucent Light

Materials such as frosted glass (or in this case, paper bags) obscure whatever may be behind them. Yet they allow soft, translucent light to penetrate. The challenge is to capture this effect in watercolor.

The reference photo shows off their very pristine colors with soft transitions from one shade to another. These soft gradations are lovely, but today imperfection is allowed and you need not concern yourself with perfect gradients. Rather, we'll use layered washes to create tints and shades that let light, personality and character show through, imperfections and all. Use confident, bold strokes where possible and careful, precise strokes where needed.

Look Into the Heart of Your Reference Photo

Study the reference photo before starting. What color is the red bag? Is it really red? Can you see any other colors in it besides plain old red? Study the other colors of the photo with the same eye. Look at the blue bag in the middle and ask yourself, how close in value is the lightest blue to white? How close in value is the darkest blue to black? The shadows in the green bag are darker than the shadows of the other bags. The glass bottle's interior shape is merely a combination of wavy shapes. Nothing is totally black and nothing is totally white, except for a few whitish reflections.

1 | Prepare the Line Drawing / Apply Masking

Sketch the shapes you see in the reference photo. Apply liquid mask to the inside edges of the bags, bottle and bowl. Because these overlap, the masking should form one continuous shape. Outside that shape is the background and foreground.

Materials

Paper
140-lb (300gsm) cold-pressed watercolor paper

Brushes
Chip brush, 1-inch (25mm), ½-inch (13mm) and ¼-inch (6mm) flats, no. 1 round

Paints
Alizarin Crimson, Burnt Sienna, Cadmium Orange, Cobalt Turquoise, Payne's Gray, Permanent Blue, Quinacridone Magenta, Ultramarine, Ultramarine (Green Shade) Winsor Green (Blue Shade), Winsor Violet

Other
Masking fluid
White gouache

Watercolor Review

- **Wet-on-wet:** Wet brush on wet paper

- **Wet-on-dry:** Wet brush on dry paper

- **Dry-on-wet:** Dry brush with pure pigment applied to wet paper

- **Dry-on-dry:** Dry brush with pure pigment applied to dry paper

- **Wet-to-dry:** Starting with a wet brush and wet paper and painting continuously until the paper is dry

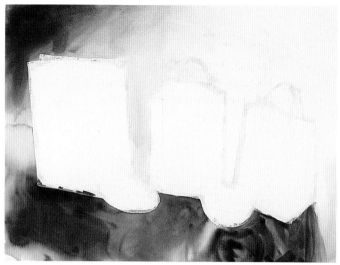

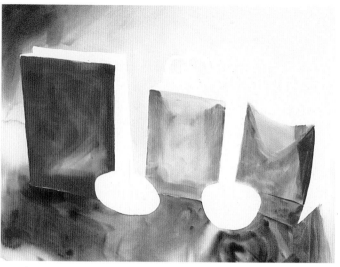

2 Paint the Background

Have all your paints and brushes ready to go. Don't spend too much time on any part of the background. Get the values and colors basically correct, but play fast and loose with the brush. Flood the entire paper except the bags, bottle and bowl using the chip brush. Rewet areas that may have started to dry as you paint (usually the edges). With the 1-inch (25mm) flat, starting from the top-middle of the paper, begin laying down paint in a counterclockwise direction. Use very light Burnt Sienna, getting darker as you move left. Add more Burnt Sienna and Permanent Blue as you go to the upper left. Continue around the left of the red bag and to the bottom, adding Alizarin Crimson and Payne's Gray in front of the red bag. Apply Cobalt Turquoise and Payne's Gray in front of the blue bag. Use Winsor Violet and Payne's Gray in front of the bowl. Add Winsor Green (Blue Shade) in front of the green bag. Make sure the values are more or less correct. After the paint has thoroughly dried, remove the masking.

Masking Removed

3 Paint the Bag Fronts

The soft gradation of tones on the bag fronts goes from dark on the outside to light toward the center. If you are right-handed, paint the bags from left to right; vice versa if you're left-handed.

Mix Winsor Green (Blue Shade) and a dash of Cadmium Orange for the green bag. Flood the front with water. Let it dry to a satin sheen. Apply a medium (40 percent) tint of the mixture. Let it dry to a satin sheen again. Keep layering darker tints (50–60 percent). Refer to the reference photo often. When the wash dries to an eggshell finish, load in the darkest tones with a green mixture heavily saturated with Payne's Gray to give it a deep color just short of black.

Flood the front of blue bag with water and let it dry to a satin sheen. With the 1-inch (25mm) flat, apply a 30 percent Cobalt Turquoise wash using a saturated brush. When the water dries to an eggshell sheen, apply a 60 percent Cobalt Turquoise wash using a damp brush.

The red bag is a combination of Quinacridone Magenta and a little Alizarin Crimson. Flood the shape with water and let it dry to a satin sheen. Apply a 40 percent layer of the red mixture and let it dry to a satin sheen. Apply progressively darker shades of the red mixture. The center of the red bag has a purplish cast, so add Winsor Violet to the reds, building it up until violet is clearly visible.

Caution

Just to the left of the shadow below the blue bowl a stream of light comes forward. Be careful not to let your washes of color bleed into it.

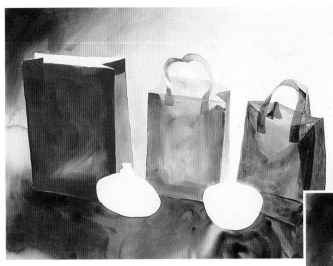

Caution

Let each shape dry before painting an adjoining shape; otherwise the colors will blend and you'll lose the beautiful edges.

4 | Paint the Bag Sides, Tops and Handles

The shapes you are about to paint are all basically a single color with variations of that single color within their shape. Use the ½-inch (13mm) and ¼-inch (6mm) flats and the same color mixtures used in step 3 for each bag. Use the edge-knocking wet-on-wet technique (page 23). Paint each shape individually. Start with any of the side, top or handle shapes. Wet the interior of the shape. Referring again to the reference photo, apply the light, medium and dark shades of the bag color into the wetted shape. Repeat with each side, top or handle shape.

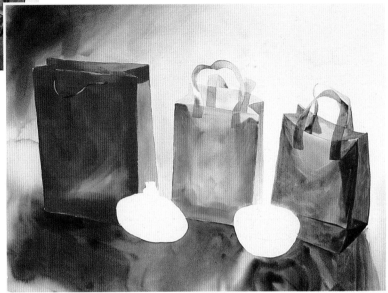

5 | Paint the Bottle and Bowl Undertones

The green-blue highlights on the upper right and the curved pinkish shape at the base of the bottle's neck are its lightest tints. A light comes through the blue bowl too, tinting it light purple.

Fill the interiors of the bottle and bowl with water and let them dry to a satin sheen. Add the bottle highlights with a ¼-inch (6mm) flat. Use Alizarin Crimson for the bottleneck and Cobalt Turquoise for the highlight on the right side. Lay down a light layer of Winsor Violet in the bowl.

Caution

Maintain the lighter tints of color; they create the sense of light.

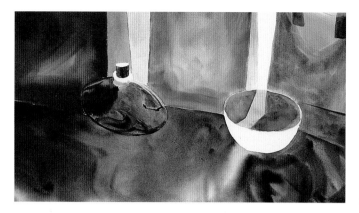

6 Finish the Bottle and Bowl

The bags are distorted within the elliptical shape of the bottles, making the greenish swirling shape at the bottom. The value ranges of the colors within the bottle go from medium to dark. The bowl's internal shapes are darker in value than the shapes in the bottle, and there is more contrast in the bowl because of the light coming through from behind. The bowl also sits in a darker shadow than the bottle.

Use the wet-to-dry technique. With the ½-inch (13mm) flat, wet the interior of the bottle and let it dry to a satin eggshell sheen. Begin adding the colors you see in the reference photo, keeping in mind their middle value ranges. (Do some tests on a scrap piece of paper before you begin.) As the paint begins to dry, add more details with a no. 1 round. Finish with dark shadows around the outer edges. Use the wet-on-dry technique to layer the progressively darker shade of Winsor Violet and Ultramarine.

7 Add the Final Touches

Using the wet-on-dry technique, add the darker shades of color to the bowl (starting with the lightest shades and going to the darkest) with Ultramarine (Green Shade) and Payne's Gray to saturate the darkest shadows. Use white gouache with a little Winsor Violet to overpaint the Payne's Gray underneath the forward rim, creating the sliver of violet light that runs along it.

Put the final touches on the bottle's opening and cork using Winsor Green (Blue Shade) for the basic color, Ultramarine (Green Shade) for the glass mouth and Burnt Sienna with Payne's Gray for the cork. Apply the line shadows at the bottom edges of the bags. Add dabs of white gouache to punctuate the painting with sparks of light.

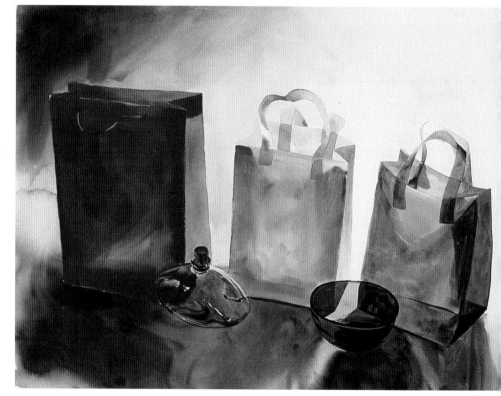

Paint Backlit Silk

Backlighting occurs when a light source is positioned behind your subject. It will make the subject, by contrast, appear darker or in shadow, and swallowed by the light coming from behind. Whenever you use translucence in a painting, you will rely on backlighting to illuminate the material of front of it.

Semitransparent fabrics are ideal for studying translucent effects. When draped over any subject they mute edges, colors and values. The secret is to break down the image into shapes (in this case, soft shapes), then deal with them individually.

Whenever you paint a subject that lacks defined edges to work within, study the image and determine which areas will be easiest to paint. Because of the absence of defined edges, you will paint areas surrounded by white. Isolate sections of the painting that you can work on without also having to deal with issues of other areas. Keep it simple.

There are five areas to work on individually: (1) the foreground, (2) the left apple, (3) the right apple foreground shadow, (4) the background and (5) the right apple.

Materials

Surface
140-lb. (300gsm) cold-pressed paper, full sheet

Brushes
Large brush for washes. 4-inch (102mm) hake, 1-inch (25mm) flat, ½-inch (12mm) and ¼-inch (6mm) Sumi-e brushes

Paints
Alizarin Crimson, Burnt Sienna, Cadmium Red, Neutral Tint, Payne's Gray, Winsor Yellow

Other
Paper towels

Reference Photo

Line Drawing
Just indicate the basic shapes.

1 Begin With the Foreground

Wet the bottom portion of the paper to a semigloss sheen. Wet the area to be painted plus a little extra, because the water dries at the outside edge first and you want to make sure it doesn't dry before you have a chance to paint it. Use a light combination of Burnt Sienna and Neutral Tint. Let dry completely.

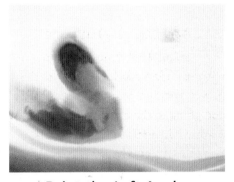

2 Paint the Left Apple

Wet the entire area including what you've already painted. Use the larger Sumi-e to apply Burnt Sienna and Neutral Tint. Let the paint express itself. In the area of the apple, use more Burnt Sienna to pull out the red coming through the silk fabric. Make sure the paint and paper dry completely before proceeding to the next step. If they don't, the existing pigment will lift off the paper and float off to places you don't want it to go.

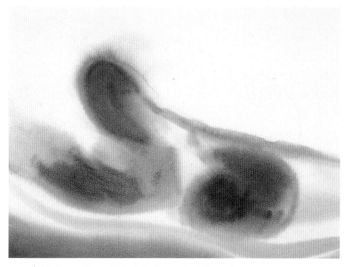

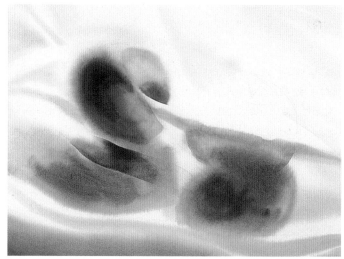

3 | Paint the Right Apple Shadow

Paint the shadow in the foreground of the apple at right the same way you painted the left one. Use Burnt Sienna and Neutral Tint in the wet-on-wet technique with greater color saturation and darker shades toward the center of the shadow. It's naturally darker in the center because that's where the light is obscured the most.

4 | Paint the Background

Use the wet-on-wet technique to add the background tints of Burnt Sienna. Paint the top of the left apple, keeping the tones very light to enhance the sense of overpowering light coming from behind. After doing this, go back and reinforce the shadow of the left apple.

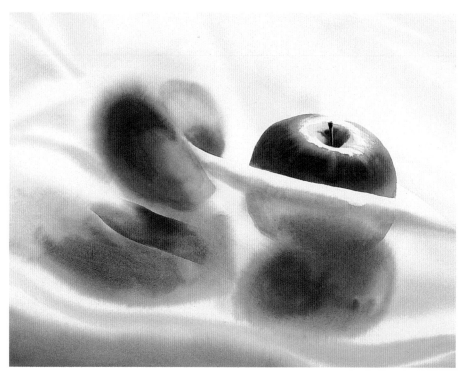

5 | Paint the Right Apple to Finish

Use the wet-on-dry technique and the large Sumi-e to paint the right apple, starting with the lightest tint. Use Winsor Yellow, Cadmium Red, Alizarin Crimson, Payne's Gray and the medium Sumi-e brush. The deeper saturation of color in the right apple is what makes this translucent effect work so well. The bright tones of the right apple make the soft tones around it look all the more silky and soft.

Paint Translucent Silk

In the previous demonstration (page 63) you painted backlit silk using watercolor. Now you'll accomplish a similar result using oils. Here, the silky fabric shrouds peppers in soft tones. It also produces gentle folds and subtle color transitions from one area to the next. This subtlety is well suited for oil painting when the paint is applied in a slippery state. You'll have to create very subtle shifts in values along with the a sharp contrast between the portion of the high-contrast yellow pepper at left (not obscured by the fabric) and the shrouded soft-value orange pepper at right.

In every step, and with every brushload of paint, add some medium and a touch of odorless mineral spirits to make the paint a little transparent and slippery. Or make a mixture of 80 percent medium and 20 percent odorless mineral spirits and stir well. Dip your brush into this mixture, then into your paint.

Materials

Surface
12" x 16" (30cm x 41cm) primed canvas board

Brushes
¾-inch (19mm), ⅜-inch (10mm) and ¼-inch (6mm) flats

Paints
Cadmium Orange Deep, Cadmium Yellow Medium, Ivory Black, Phthalo Green (Yellow Shade), Titanium White

Other
Craft knife
Medium
Mixing containers
Odorless mineral spirits
Packaging tape
Paper towels

1 Prepare the Drawing and Apply Masking

Prepare a light sketch of the peppers with the slightest indication of the silk around them. Transfer the sketch onto the canvas board. Cover this area with clear packaging tape, then cut out the peppers' contours with a craft knife. (Don't press too hard or you'll cut through the canvas board).

2 Begin the Background Silk

The silk fabric passes behind and in front of the peppers in wavelike undulations. Use broad sweeping paint strokes for that. With Titanium White and a touch of Cadmium Yellow Medium, apply the light yellow tones at the top of the image with a ¾-inch(19mm) flat. With the same paint mixture, add slight amounts of Ivory Black to match the subtle color shifts in the fabric. Let your brushstrokes flow. The hills of the silk form a natural line that separates the background folds from the foreground folds. Use this line as a stopping point so you can focus on the foreground silk.

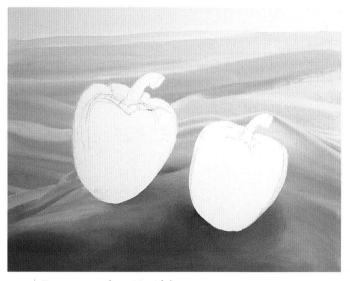

3 | Begin the Foreground Silk

The foreground silk is somewhat darker than that in the background. Apply mixtures of Cadmium Orange Deep and Cadmium Yellow Medium to the foreground to match the hints of yellow and orange around the peppers.

Just as you did with the background silk, apply smooth, flowing strokes of paint, paying close attention to the subtle color shifts. Use a smaller brush for the smaller areas; add Ivory Black and Titanium White to Cadmium Yellow Medium to adjust the values.

4 | Remove the Masking

Remove the mask of clear packaging tape. You preserved the contours, so you don't have to redraw the peppers.

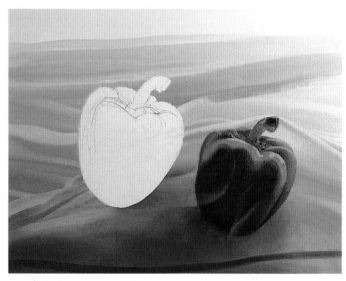

Caution

Avoid painting the highlights white. Look closely and you will notice that the lightest tones have hints of gray in them. Capturing this subtlety helps express the translucence of the silk.

5 | Paint the Right Pepper

Use the Pro Paint-by-Number technique (page 36) with Cadmium Orange Deep, Cadmium Yellow Medium, Ivory Black and Titanium White. Use larger brushes for the larger areas and smaller ones for smaller areas.

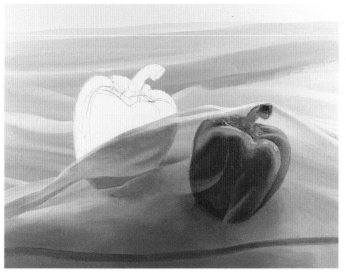

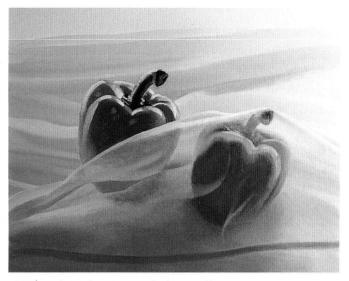

6 | Paint the Bottom of the Yellow Pepper

Paint the veiled part of the yellow pepper at left with Ivory Black, Titanium White and Cadmium Orange Deep. Select brushes that feel easy and natural to work with. Blend the edges of the pepper and silk so the fabric appears continuous in front of the pepper.

7 | Paint the Top of the Yellow Pepper

Give the highlights sharper edges and really punch up the color to make the upper half of the left pepper appear slick and glossy. Hard or abrupt edges between highlights, midtones and shadows create a glossy look, whereas soft edges between highlights, midtones and shadows create a satin sheen.

Apply the midtones and shadows first, then add the highlights. Use a ¼-inch (6mm) flat for small sparkles of color. When finished, stand back and look at the whole picture. Ask yourself if it needs any fine-tuning.

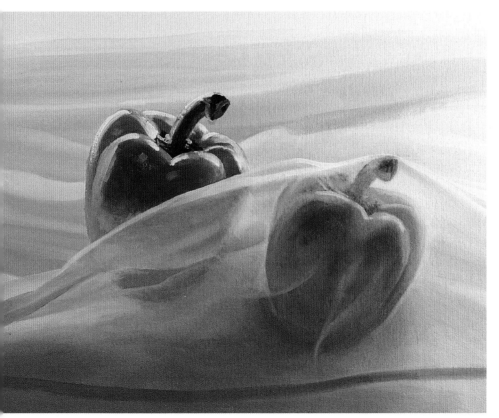

8 | Fine-Tune Your Painting

The right pepper needed more integration with the fabric. I softened its contour so it merged with the surrounding fabric in a more convincing way. Consider the places that need work on your picture and adjust accordingly.

Create Spectral Light with Stained Glass

Monks in Gothic times believed that beautiful things, such as the stained glass windows that filled their cathedrals, brought them closer to their creator. In modern times, psychologists and behavioral scientists have studied the effect *spectral light* (the translucent, colored light that passes through stained glass) has on humans. They have found that indeed colored light produces mind- and emotion-altering effects.

Stained glass is essentially no more than a tint of color overlapping a blurry background or image. Use the photo of a vase of flowers (wilted but willing) to complete this demonstration.

Materials

Surface
140-lb. (300gsm) cold-pressed paper, half sheet

Brushes
A chip brush, 1-inch (25mm) and ¼-inch (6mm) flats, ¾-inch (19mm) and ¼ inch (6mm) Sumi-e brushes

Paints
Alizarin Crimson, Burnt Sienna, Burnt Umber, Cobalt Turquoise, Payne's Gray, Quinacridone Magenta, Ultramarine, Winsor Green (Yellow Shade), Winsor Yellow

Other
Masking fluid
White gouache

Reference Photo

1 | Paint the Flowers, Vase and Background

In one wet-to-dry layer, paint the entire vase of flowers using the ¾-inch (19mm) Sumi-e. (Don't worry about subtleties; from behind stained glass they wouldn't be apparent). Paint the background behind the flowers too. Flood the entire paper to a semigloss sheen. Apply the background tones behind the vase using Burnt Sienna, Winsor Green (Yellow Shade), Payne's Gray and Winsor Yellow. Let it dry. Flood the paper and let dry to a semigloss sheen again. Add blossoms using Quinacridone Magenta, Winsor Green (Yellow Shade), Payne's Gray and Winsor Yellow. As the paper gets drier, add those same colors into the areas that need drier (satin sheen) paper, such as the leaves and stems.

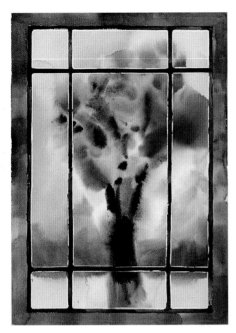

2 Paint the Lead

Add black lines using a ¼-inch (6mm) flat over the vase to simulate the lead material between the panes. Paint the lead Payne's Gray, then outline it with random dashes of white gouache. Create warm brown and rust tones using Ultramarine and Burnt Sienna to add an outside window frame. That will contrast nicely with the brightly colored flowers.

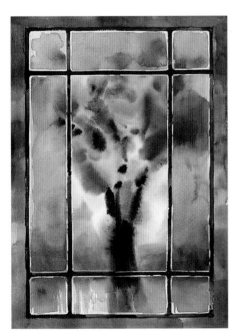

3 Paint the Outer Windowpanes

In the outer windowpanes, apply a light tint of Cobalt Turquoise using a 1-inch (25mm) flat.

4 Age to Finish

Use a ¼-inch (6mm) flat and white gouache to paint random streaks on the window to suggest aging and condensation.

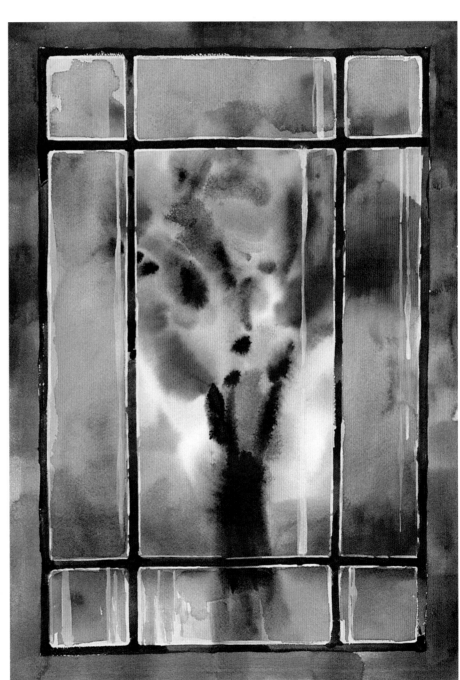

Use Translucent Light for Simple Drama

There's an old, rustic carport that I often walk past. When the light is low during summer evenings, the sun filters through the trees and imprints their silhouettes upon the carport window. The filtered light embraces whatever it touches and turns what would be a so-so composition into a dramatic one.

I occasionally stand watching the light coming through the window. One day, I went up to the house to ask permission to take some photos but nobody answered the door. It took less than thirty minutes to set up my tripod and photo gear. I brought a box of objects from home to place on the windowsill.

This composition's strength is in the contrasting of elements: light against dark, soft against rough and elegant curves against hard rectangular edges.

Reference Photo
Draw a grid on the reference photo and a larger corresponding grid on your paper. Then lightly draw the main structural lines of the image on the watercolor paper.

Materials

Surface
140-lb. (300gsm) cold-pressed paper, full sheet

Brushes
2½-inch (63mm), 1-inch (25mm) and ¼-inch (6mm) flats, ¼-inch (6mm) bristle (oil), no. 7 and no. 1 rounds

Paints
Alizarin Crimson, Burnt Sienna, Cadmium Orange, Payne's Gray, Ultramarine (Green Shade), Winsor Green (Yellow Shade), Winsor Yellow Deep

Other
Straightedge
White gouache

1 | Begin With the Glass Windowpanes

The light in the window is mottled. Diffused branches give way to the light, so allow lots of white. The color doesn't have to be exact; it just has to be light, pleasing and consistent.

Use the wet-on-wet technique and begin by wetting the lower left pane with a 1-inch (25mm) flat. When it dries to a satin sheen, dab in a light combination of Alizarin Crimson, Winsor Green (Yellow Shade), Cadmium Orange, Ultramarine (Green Shade), Burnt Sienna and Payne's Gray with a ¼-inch (6mm) bristle. With enough water, a light mixture of these colors makes a light gray tone. Load the first brush of paint with a neutral gray mixture, the next with a slight gray-brown mixture, the next with a slight gray-green mixture, and so on. Continue this technique, moving from one pane to the next.

Caution
Make sure the paper is sufficiently satin wet so the paint disperses in step 1.

Caution
With each adjoining pane, make sure the colors cross over correctly. That is, if the edge of one pane has a brownish red gray cast, then the adjacent pane must also have that color at the adjoining edge.

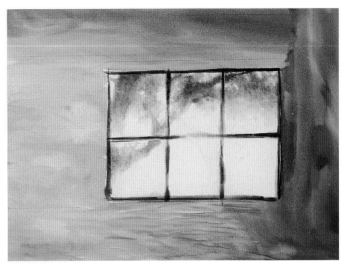

2 | Paint the Window Sashes

The sash contours appear to undulate because the light bends around them, so don't make them exactly straight. Make a mixture of brown and brown-black using Burnt Sienna and Payne's Gray. With a ¼-inch (6mm) flat, wet the areas in which the sashes will be painted with a wet-on-wet technique. Align a straightedge along any of the lines of sashes. Paint the sashes using the same flat. Turn your brush a little sideways to paint the narrower areas. Do a dry run first with the straightedge and a dry brush to make sure everything feels right. Pay special attention to where the values are lighter and darker.

3 | Begin the Rough Wood Wall Undertones

The light on the wall gets warmer as it moves to the left. Study the grain of the wood—you'll want to paint it in an understated manner. To do this, you'll lay down an undertone wash, paint the wood grain over that, then add an overtone wash to unify the wall and soften the wood grain.

Wet the entire wall. With the 1-inch (25mm) flat, begin adding tones of Cadmium Orange, Burnt Sienna, Winsor Green (Yellow Shade), Payne's Gray, Ultramarine (Green Shade) and Alizarin Crimson. Mix the colors in the values you see in the reference photo. Let it dry.

The rough wood wall looks pretty drab at this point, but that's OK because you'll bring in stronger colors later.

Caution

Don't worry about making perfect blends of the colors in step 3. Do pay attention to the values of the colors.

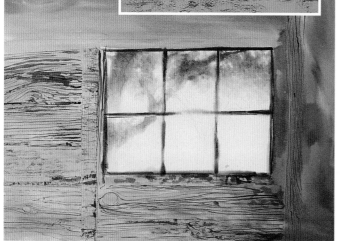

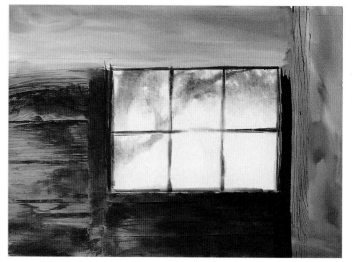

4 Paint the Wood Grain Lines and Textures

Wood grain is composed of three basic elements: thin lines, textures and splotches. Most of this grain is very fine. It's most visible in the sunlit part of the wall, while it's hidden in the shadow areas. Just suggest the grain. Position a no. 1 round straight up and down and gently draw the thin lines with the very tip of the brush. Go slowly and don't draw every line. Let your brush glide naturally. Add a second layer using the wet-on-dry technique with Burnt Sienna and a touch Payne's Gray to create the textures. Using the flat side of a ½-inch (13mm) bristle, gently drag and dab, exposing the texture of the paper. Test this effect on a separate piece of paper first, if you want to practice. Don't put too much water or paint on the brush; use just enough to leave an irregular texture. Let it dry.

5 Add the Splotches and Wood Grain Overtones

Flood the wood grain area and let it dry to a semigloss. With the 1-inch (25mm) flat, dab the splotchy areas with Burnt Sienna and a touch of Ultramarine (Green Shade). Let the paint dry.

Work wet-to-dry and light-to-dark for the overtones. Flood the entire wood grain areas again and let them dry to a semigloss. Starting at the left side where the color is lightest, apply a mixture of Winsor Yellow Deep and a touch of Burnt Sienna with the 1-inch (25mm) flat. Gradually add more saturated amounts of Burnt Sienna as you move to the right. Continue under the window and add even more Burnt Sienna with Alizarin Crimson. For the darker tones, add Ultramarine (Green Shade). For the darkest areas add heavy amounts of Payne's Gray to the mixture. As the paper dries, fortify the wood textures in the lighter areas by gently dragging the 1-inch (25mm) flat on its side with the darker colors. Use a no. 1 round to paint the darkest side of the window.

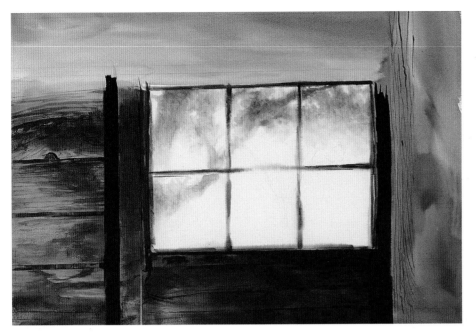

6 | Add Finishing Touches to the Rough Wood Wall

With a no. 1 round, paint the darkest cracks with Payne's Gray. Apply a *single edge bleed* (a stripe of paint that has a hard edge on one side and a bleed edge on the other) to the left side of the post to the left of the window using Payne's Gray and a no. 7 round. Use a straightedge to steady your hand while painting the shadow.

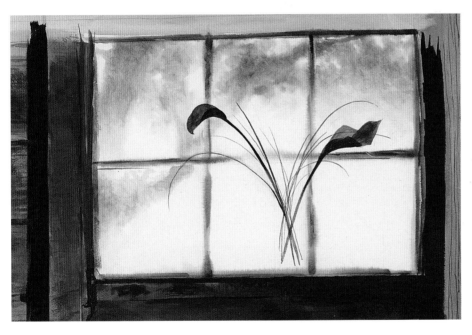

7 | Paint the Lilies' Detail

Subtle changes in value occur in the colors of the lilies' blossoms and stems. You want to capture these nuances. Do the blossoms first, then the stems and grasses. Practice painting the refined, arcing lines of grass on a separate piece of paper. Either plant the heel of your hand on the paper (use a protective paper barrier between your hand and the painting), or float your hand above the paper and freely draw the arcs.

With a ¼-inch (6mm) flat and a medium-value mixture of Payne's Gray and Alizarin Crimson, paint the blossoms. Use a no. 1 round to grow your stems upward. (It's OK to paint them from the top down too. The important thing is that you paint the stems and grasses in a way that feels comfortable and natural to you.)

Caution

Avoid creating a hard black silhouette on the lilies that looks crude and pasted on.

8 | Paint the Vase

The vase has light, medium and dark values with hard and soft edges. Wet the inside of the vase and let it dry to a semigloss or satin finish. Begin painting the modulations in the glass with a no. 1 round and a mixture of Ultramarine (Green Shade) and Payne's Gray. Proceed from the lightest values to the darkest adding Winsor Green (Yellow Shade) to the stems. Use Payne's Gray to paint the darkest parts of the grasses.

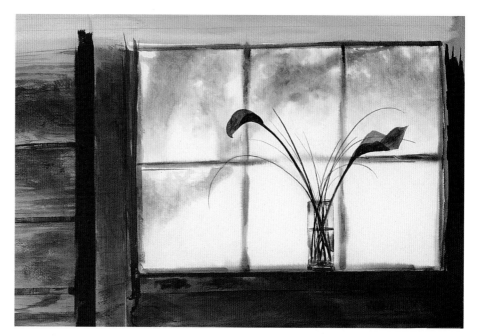

9 | Paint the Top and Right Side Shadow Undertones

The major shadows are pretty dark with hints and suggestions of wood grain. Paint them in three layers: undertones, wood grain and overtone shadows.

For the undertones, flood the shadow areas and let them dry to a semigloss sheen. With the 1-inch (25mm) flat, begin adding heavily saturated amounts of Winsor Green (Yellow Shade), Ultramarine (Green Shade), Burnt Sienna and Payne's Gray. Let it dry.

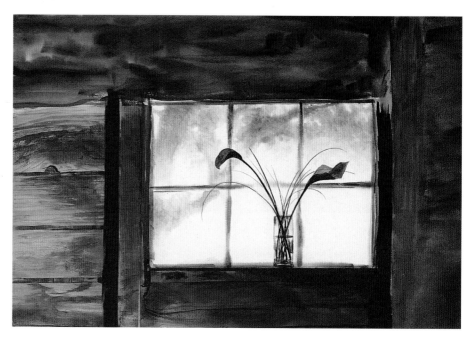

Caution

The glass panes have very light tones, so make sure you don't overdo the color saturation. It would look odd, for example, if one pane had a bluish cast and the next pane had a greenish cast. (You might wonder, why not just paint the entire tree scene and then paint the grid of window sashes over it? Well, there's no reason not to. Give it a try.)

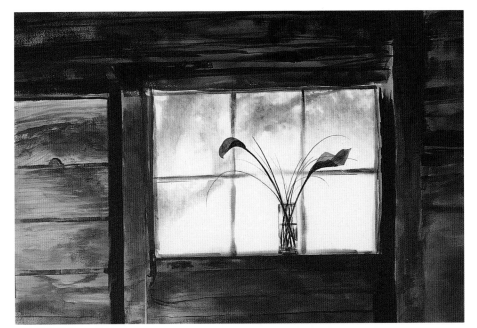

10 | Paint the Major Shadowed Wood Grain

Use the wet-on-dry technique and the 1-inch (25mm) flat to add wood grain in random patterns with Payne's Gray. Since the pattern of the grain is not clearly visible in the photo, invent your own.

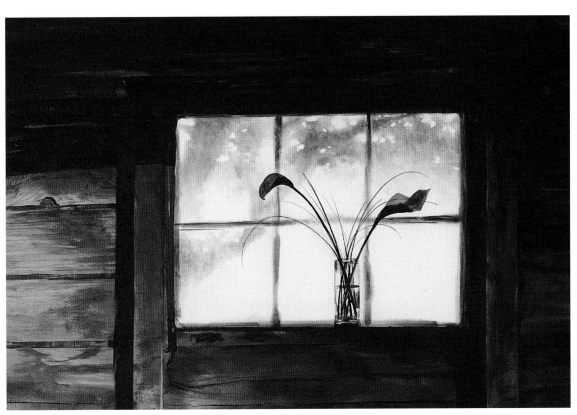

11 | Finish With Shadow Overtones

For the overtones, use the wet-on-dry technique to apply Payne's Gray in the darkest areas. Use a straightedge to paint the edges of the post at right.

Add highlights with white gouache where the sun comes through the trees. The gouache is whiter than the paper, so add a very tiny amount of Winsor Yellow Deep to match the paper. Erase any remaining pencil lines.

Luminosity

Who doesn't love things that glow? Luminous light comes in many forms: from a glorious sunset filling the horizon to a single candle illuminating a nearby book. Throughout art history, capturing the luminous qualities of a glowing light source has been the delight of many artists and, to an extent, a measure of their capability.

Radiance seems to come from inside luminous paintings. This radiance inspires children to paint the sun with lines coming out of a ball. It inspired Van Gogh to paint concentric rings around the sun and stars to portray the outward movement of their rays.

In this chapter, you'll take your brushes into the warm glow of radiant light and learn to paint with dramatic results.

Paint Luminous Backlighting

Most paintings have, or at least suggest, a light source. But when painting luminosity, you're looking directly at or into the light. This creates optical distortions in which light actually appears to wrap around any subject near it. The distortions follow what I call the *luminous principle*: light is brightest (whitest) at its source. From the source, lighter tints of color bleed outward and get progressively darker the farther they get from the light source.

These pears are lit from behind. The light is so strong that it appears to wrap around the pears like fingers. Enfolding luminosity engulfs everything around it. When you learn to paint convincing backlighting, you're on your way to creating a luminous presence that makes subjects seem inside its brilliance.

Materials

Surface
140-lb. (300gsm) cold-pressed paper, half sheet

Brushes
¾-inch (19mm) and ¼-inch (6mm) Sumi-e brushes, a small round

Paints
Alizarin Crimson, Burnt Sienna, Payne's Gray, Winsor Green (Blue Shade), Winsor Yellow Deep

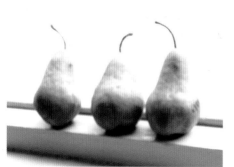

Reference Photo

Prepare the Drawing
Roughly indicate the shapes of the pears on the windowsill.

1 Begin With the Undertones

The pears have irregular shapes and textures. Undertones help simulate that. Transfer your drawing to your watercolor paper. Wet the pear shapes and apply undertones with a ¼-inch (6mm) Sumi-e. Zoom in and look at your subject closely and try to detect what subtle colors are hidden there. I saw shades of Winsor Green (Blue Shade), Winsor Yellow, Alizarin Crimson and Burnt Sienna.

Caution

You want the white of the paper to be dominant, so don't allow your colors to spread into the white areas.

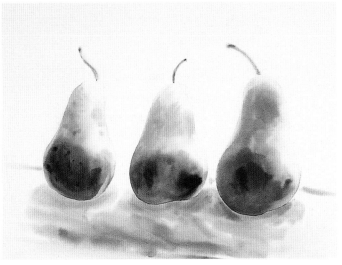

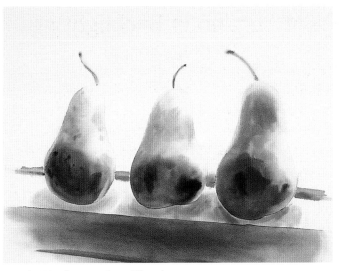

2 | Fill Out the Shapes

Fill each pear shape with water and let dry to a semi-gloss sheen. Apply Burnt Sienna, Alizarin Crimson and Payne's Gray into the wetted areas with a ¼-inch (6mm) Sumi-e, paying particular attention to the values—lighter tones in the highlights and darker ones in the shadows.

Wet the areas above the pears and let dry to an egg-shell sheen. Add the stems with a small round. Don't let the stems bleed much. Wet the area below the pears where you'll paint in the shadows. Add real colors or colors you imagine into those areas. These colors will serve as the windowsill undertones.

3 | Work on the Shadows

Wet the pears and the foreground sill and cover those areas with a combination of Payne's Gray and Burnt Sienna using a ¾-inch (19mm) Sumi-e.

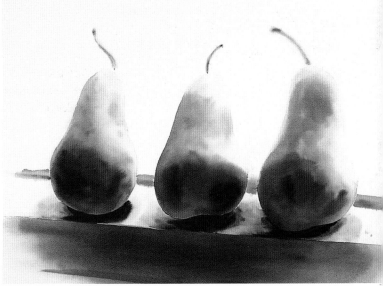

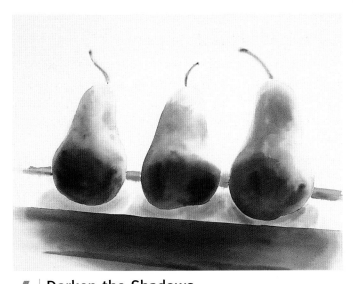

5 | Add the Darkest Shadows to Finish

To add the darkest shadows under the pears, wet the sill areas and apply Payne's Gray. Let the color bleed a little on the sill but not onto the pears. Stand back and voila! The white of the paper gives the appearance of light because you let it spill into the space of the pears.

4 | Darken the Shadows

The shadows still could be darker. Wet the pears and the foreground sill again and saturate those areas with a combination of Payne's Gray and Burnt Sienna.

Remember that watercolors dry a lot lighter than when they are first applied, so you always have to apply them with more pigment than you think you need.

Paint the Surrounding Glow of Candlelight

Candlelight can be romantic, mysterious and even spooky. Everyone loves the effects of candlelight. It is close, intimate and dramatic and provides endless opportunities for luminous painting. Not only does the flame itself glow, the surfaces surrounding the flame glow as well. This surrounding glow is one of the keys to successfully painting luminosity, as this method of painting works not only for candlelight but for all concentrated light sources. The colors are lightest closest to the flames or light source. They get progressively darker the farther from the flames or light source they are.

Materials

Surface
140-lb. (300gsm) cold-pressed paper, full sheet

Brushes
1-inch (25mm) flat, ½-inch (12mm) Sumi-e

Paints
Alizarin Crimson, Burnt Sienna, Cadmium Orange, Payne's Gray, Winsor Yellow Deep

Other
White gouache

Reference Photo

Prepare the Drawing
Include the shapes that surround the candles in your drawing.

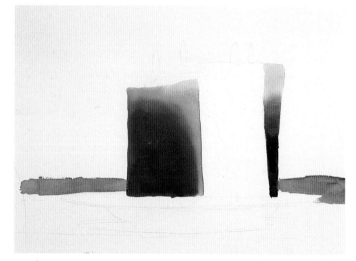

1 | Begin the Candles and Background

Flood a few of the nonadjoining candles with water, then let them dry to a semigloss sheen. With the 1-inch (25mm) flat, apply Winsor Yellow Deep. From the top, progress downward applying Cadmium Orange, then continue with a mixture of Alizarin Crimson and Burnt Sienna. Add the same mixture again plus Payne's Gray at the bottom.

Begin the background with a little Alizarin Crimson applied wet-on-wet with a semigloss sheen.

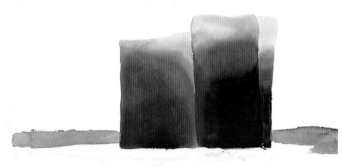

2 | Paint the Center Candle

Repeat step 1 with the center candle, but notice that the center candle has a darker shadow so you'll have to really load on the Payne's Gray to achieve the right shade.

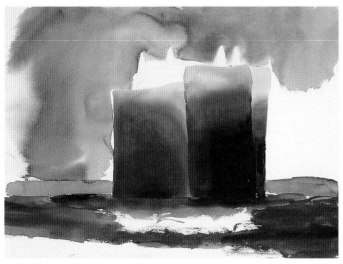

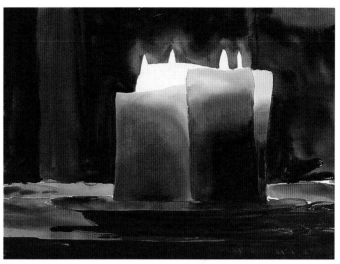

3 | Continue the Background and Begin the Foreground

Use the wet-on-wet technique to lay on the Alizarin Crimson undertones in the background. Apply Burnt Sienna and Payne's Gray in the foreground. Use a ½-inch (12mm) Sumi-e.

4 | Darken the Background

Flood the entire background and let it dry to a semigloss sheen, then lay in progressively darker shades of Payne's Gray. Be careful not to encroach into the flame area with dark tones. In the places nearest the flames mix the paint thin and transparent so the surrounding red color shows through, maintaining the glow.

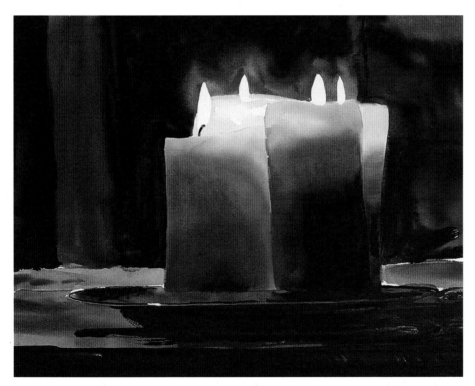

5 | Finish the Painting

Finish off the farthest candle with a little Winsor Yellow Deep. Punctuate the flames with white gouache, painting their edges sharp and crisp. Add glints of highlights on the plate below the candles. Add a wick to the candle on the left using the 1-inch (25mm) flat and Payne's Gray, and you're finished.

An Exercise in Value Range Control

The face of the moon is scarred from the impact of meteors and asteroids from eons ago, yet it never ceases to be beautiful. There's a vigilant and guardian quality in its light. The moon illuminates the night with beauty and grace regardless of its violent past.

You don't need a large palette to capture this luminosity. Study the moon and surrounding clouds in the reference photo. The areas closest to the moon are brighter; the areas farthest away are darkest. Imagine that you can see lots of dark, subtle colors in the clouds. You'll practice creating this wide range of values with only a few colors in this demonstration.

Materials

Paper
140-lb (300gsm) cold-pressed paper, full sheet

Brushes
Chip brush, ¾-inch (19mm), ½-inch (12mm), and ¼-inch (6mm) Sumi-e brushes

Paints
Burnt Sienna, Payne's Gray, Ultramarine Blue

Other
Masking fluid

Reference Photo
I always carry my camera. On this night, the clouds parted and I looked up and shot. The image is blurry, but I took home the sharpness of the scene in my mind. Don't worry too much about an accurate line drawing here. Just look for the basic shape of the scene.

1 | Prepare the Undertones
Mask the moon. Use the large chip brush to flood the paper with water. Apply undertone dabs and strokes of Ultramarine Blue and Burnt Sienna with a ½-inch (12mm) Sumi-e.

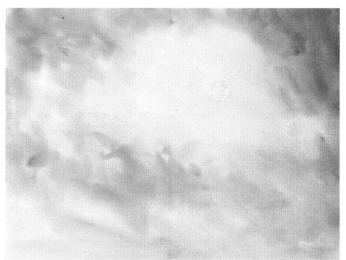

2 | Apply a Second Undertone
Apply another undertone layer using a flood of Ultramarine Blue with the ½-inch (12mm) Sumi-e. This will soften the highlights in the clouds, causing the moon to appear all the more brilliant in contrast.

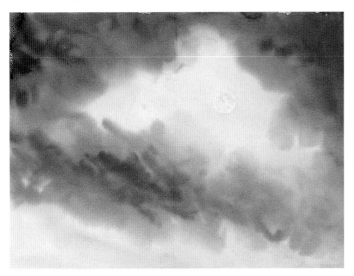

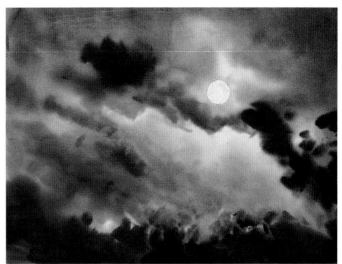

3 | Paint the Midtones

Look at the reference photo and make a mental note of where the midtones are. Apply the same colors you used in step 2, with the addition of hints of Payne's Gray. Let the colors gradually darken and become less diluted to get the midtones.

4 | Begin the Darkest Tones

Generally block in the dark tones using Payne's Gray and a ½-inch (12mm) Sumi-e.

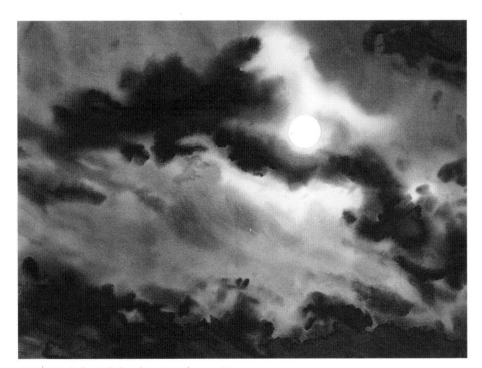

5 | Finish With the Darkest Tones

Lay in the final layer of Payne's Gray. Apply heavy amounts in the darkest areas. Be sensitive to where you want this dark color to encroach into the clouds and where you want to keep it away. Let it dry, remove the masking and you're finished.

Caution

Maintain the lightest tones in the clouds closest to the moon. One of the lessons in this demonstration is to exercise your skills in creating distinct highlights, mid-tones and darks.

Capture Glowing, Sunlit Interiors

Luminosity makes interiors glow. I've been up and down these stairs a thousand times. Then one day the sun shone through in a certain way and *bam*! It became a scene that demanded to be painted. Interior architecture is especially dramatic when sunlight shines on walls and ceilings. This narrow stairwell afforded a very tight, angular composition that has a contemporary abstract quality. I rarely paint angled compositions, but this scene was just too cool.

In every step, and with every brushload of paint, add some medium and a touch of odorless mineral spirits to make the paint a little transparent and slippery. Or make a mixture of about 80 percent medium and 20 percent odorless mineral spirits and stir well. Dip your brush into this mixture, then into your paint. Use a straightedge to ensure straight lines, and use soft hair flat brushes of sizes appropriate to the areas you're painting.

Materials

Surface
Pre-stretched and primed canvas

Brushes
⅜-inch (10mm), ½-inch (12mm) and ¼-inch (6mm) soft hair flats

Paints
Burnt Sienna, Cadmium Orange, Cadmium Yellow Deep, Ivory Black, Manganese Violet, Quinacridone Magenta, Titanium White, Ultramarine Violet

Other
Medium
Mixing containers
Odorless mineral spirits
Paper palettes (1 or 2)
Straightedge

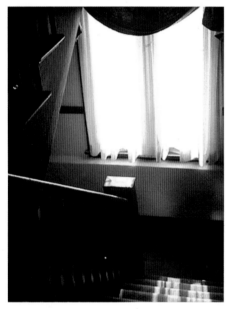

Reference Photo

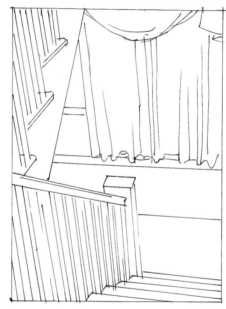

Begin With a Drawing
Transfer the image to the canvas from the reference photo using the scaling grid method (see page 26).

1 | Begin With the Darkest Tones

Since the canvas is already white, it can stand in as the sunlight for now. Paint the darkest blacks using Ivory Black with a mixture of medium and odorless mineral spirits. Use a straightedge where necessary.

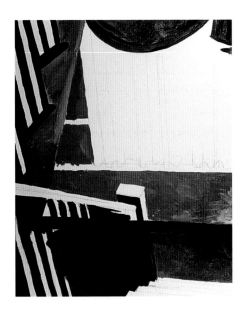

2 | Add the Middle Tones
Rough in the midtones with mixtures of Cadmium Orange, Cadmium Yellow Deep, Quinacridone Magenta and Manganese Violet. For the darker midtones, add a hint of Ultramarine Violet.

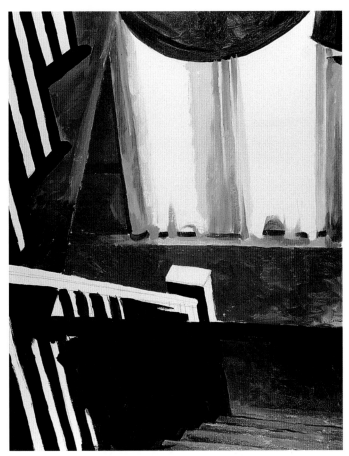

3 | Progress to the Lighter Tones
Continue adding the midtones and begin to include the lighter ranges by adding Titanium White to the mixtures. In the foreground stairs, add a little Burnt Sienna. Use Titanium White for the sunlit window.

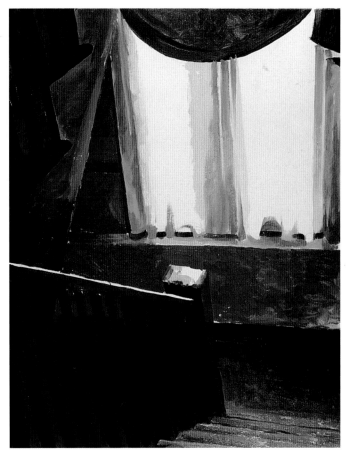

4 | Define the Railings
Use the ½-inch (12mm) soft flat and a mixture of Ivory Black and Burnt Sienna to define the railing shapes. Make sure the vertical rail slats are evenly spaced.

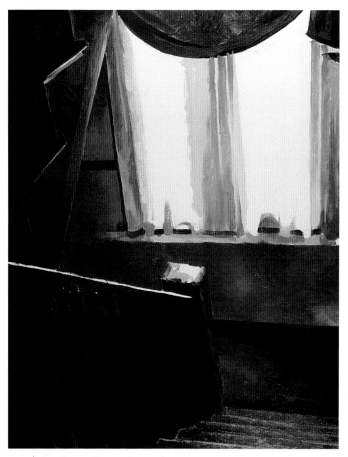 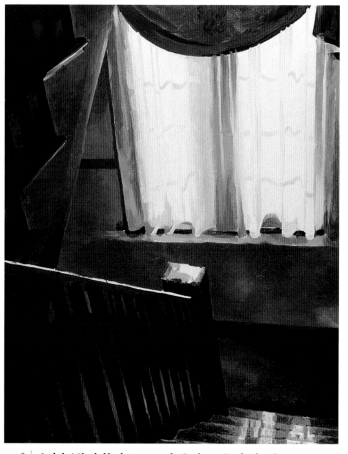

5 Refine the Glow

Using the same colors, repeat step 2, only spend more time blending tones carefully to create a soft glow. To do this, gently oscillate your brush, as if you are polishing. This will gently blend the colors. Naturally, you will want the lightest blend of colors nearest the light source.

6 Add Highlights and Color Subtleties

Add the super-light color subtleties in the curtains and the yellow highlight on the foreground stairs. For the vertical slats of the railing use a mixture of Cadmium Orange and Cadmium Yellow Deep. Use a pale tint of Cadmium Yellow to paint the window sashes behind the curtain.

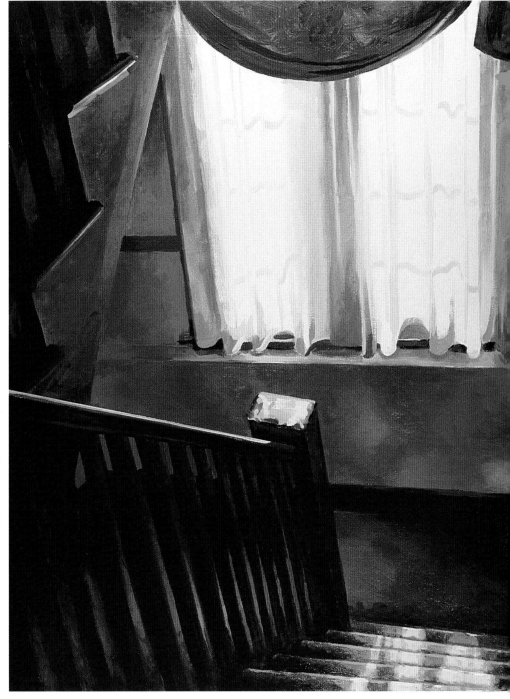

7 | Add the Finishing Touches

With a straightedge, go through the whole painting and tighten up everything. Add highlights of Titanium White in the curtain. Paint the edge where the curtain overlaps the window nice and sharp, using a mixture of Burnt Sienna, Quinacridone Magenta and Titanium White. Sharpen the light reflection on the railing with Titanium White, Cadmium Yellow Deep and a touch of Quinacridone Magenta. Straighten any wobbly edges, look for places to punch up the colors a little and you're finished!

Paint a Street Scene With Glowing Lights

Cityscapes at night offer the artist the unique effect of car lights, streetlights and lights from shop windows. They provide the opportunity to explore the dramatic relationship between light sources and the surrounding darkness. As with all luminous subjects, you'll create a glowing effect in the form of light and soft colors immediately surrounding all light sources.

Materials

Paper
Arches 140 lb. (300gsm) cold-pressed paper, full sheet

Brushes
Chip brush, various 1-inch (25mm), 3/8-inch (10mm) and 1/4-inch (6mm) flats, no. 2 round, and a 1/2-inch (12mm) Sumi-e brush

Paints
Alizarin Crimson, Burnt Sienna, Cadmium Orange, Payne's Gray, Ultramarine (Green Shade), Winsor Yellow, Winsor Green (Blue Shade), Winsor Green (Yellow Shade)

Other
Masking fluid
White gouache

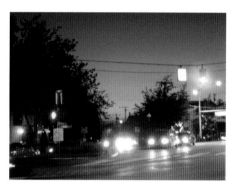

Reference Photo

Prepare the Drawing
The image is divisible into three sections: the bottom portion composed of the street and lights, the sky, and the trees that separate the two. You will work on each section independently.

Caution

Whenever you're depicting an area adjacent to a light source, make your paint mixture thinner to create the necessary glow the lights must have. If the paint is too dark near the light source, wet the area and mop up the dark colors with a dry brush.

1 | Begin With the Bottom Section

Transfer the sketch to your paper. Mask all the light sources (car lights, streetlights, etc.). Flood the bottom portion with water and let it dry to a semigloss sheen. You want this painting to be loose and expressive, so apply the colors from light to dark in quick, gestural strokes. Use a ½-inch (12mm) Sumi-e and Ultramarine (Green Shade), Payne's Gray, Cadmium Orange, Alizarin Crimson, Burnt Sienna, Winsor Green (Yellow Shade) and Winsor Green (Blue Shade).

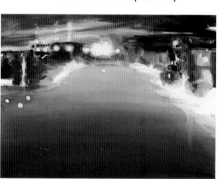

2 | Paint the Night Sky

Turn the painting upside down so the sky's edge is closest to you. Then tip up the far edge 3 to 6 inches (8cm to 15cm) so the board slants downward toward you.

Apply a wash of water in the sky area so any water runs toward you and not toward the area you've already painted. After the paper is uniformly wet, apply washes of color from the lightest part of the sky (the horizon) to the darkest part of the sky (the edge nearest you) using a wide, flat 1-inch (25mm) or wider brush with a mixture of Burnt Sienna and Alizarin Crimson. Add Payne's Gray for the darkest areas. Start at the top (the horizon) and work the slanted paper downward. Leave the board tilted until the paint has dried.

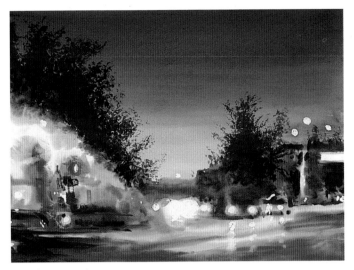

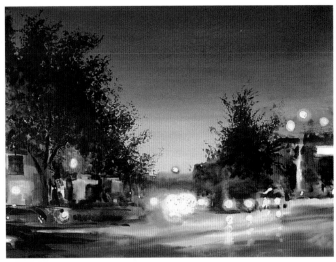

3 | Paint the Trees

Return the painting to its upright position. Using very light tints of Burnt Sienna, stipple in the tree leaves where they appear lightest at the trees' outer edges. Continue stippling using progressively darker shades and adding Payne's Gray.

Make the leaves smaller at the horizon and slightly larger toward the foreground to help create depth. Don't bring the trees all the way to the streetlight and building level. You'll do that later.

4 | Connect the Trees and Buildings

Connect the trees with the building and street area using Burnt Sienna, Payne's Gray and Winsor Green (Yellow Shade) and a combination of local washes, dabs and stipples. Maintain the light tints that cause the glow around the lights. Let it dry and remove the masking.

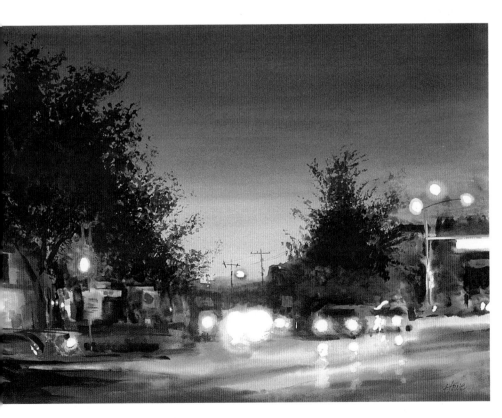

5 | Touch Up to Finish

Zoom out and look at every area of the painting and consider where it needs to be touched up. Add white gouache in the white light areas. White gouache is whiter than most watercolor paper so it will make the white areas really pop.

Neon Lights Illuminate the Luminous Principle

Neon lights offer extreme examples of the luminous principle (page 78). From the bright source, lighter tints of color bleed outward and get progressively darker the farther they get from the light source.

To best show the red and orange neon in this vintage entrance sign, make the neon tube whitish yellow and outline it with a thin line of orange. Then outline the orange with a thin line of red. Finally, surround the whole thing with dark background tones. The resulting relationship between the whitish yellow neon center and the transition to the black tones is very dramatic.

Materials

Surface
140-lb. (300gsm) cold-pressed paper, full sheet

Brushes
3/8-inch (10mm) flat, no. 2 round and 1/2-inch (12mm) Sumi-e brush

Paints
Alizarin Crimson, Cadmium Red, Payne's Gray, Winsor Yellow

Other
Masking fluid
Yellow gouache

Reference Photo

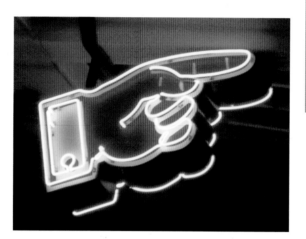

1 Apply the Masking

Draw the image on your paper. Apply masking fluid to the white neon tubing. Be sure to remove the masking as soon as your painting is complete.

2 Begin With the Lightest Colors

Apply the lightest colors first. In this case, use Winsor Yellow Deep. Use any wide brush to flood the inside of the hand area with water. Let it dry to a semigloss sheen. Using a 3/8-inch (10mm) flat, apply the yellow and add accents of Cadmium Red. Let it dry. It's OK if the yellow bleeds here and there. You will soon cover it with red anyway.

3 | Paint the Inside Contour

The contour of the hand forms a convenient shape that allows us to focus first on the inside. With a ½-inch (12mm) Sumi-e, paint the inside of the hand area. Use Cadmium Red and Alizarin Crimson for the red color, and Payne's Gray for the shadow color. When painting close to the edges, switch to a ⅜-inch (10mm) flat for more control.

4 | Begin the Surrounding Area

Wet the area surrounding the hand's contour and apply Alizarin Crimson, Cadmium Red, then Payne's Gray in the shadows using a ½-inch (12mm) Sumi-e. Let it dry. Do not try to render the background in detail. Just make gestural strokes. This will make the background look out of focus, and by contrast, the hand in the foreground will seem all the more in focus.

5 | Finish the Background

Flood the remaining area with water and let it dry to a semigloss sheen. Apply Payne's Gray with a ½-inch (12mm) Sumi-e. Use a ⅜-inch (10mm) flat near any hard edges without masking. Scrape out some Payne's Gray with the scraping end of a flat brush to show the background lines to the right of the hand. Let it dry and remove the masking fluid.

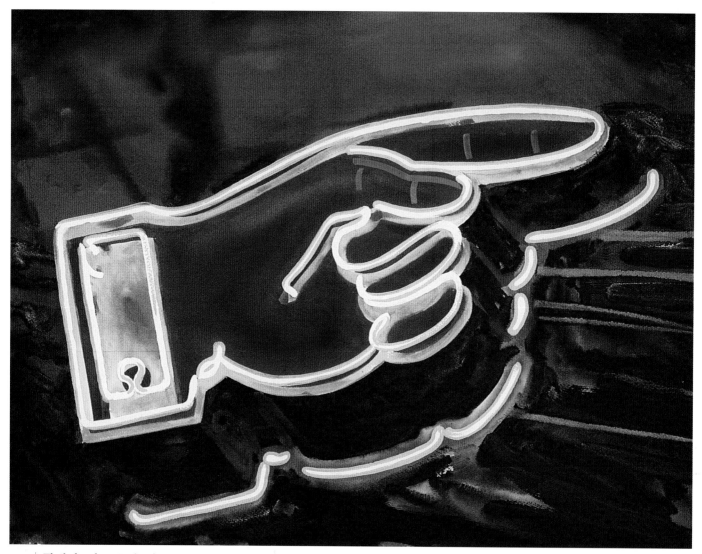

6 | Finish the Painting

A yellow glow surrounds the white neon in the reference photo. To capture this important nuance, use a no. 2 round to apply a thin line of yellow gouache around the white neon areas. Yellow gouache is better for this than yellow watercolor paint because gouache is more opaque.

Paint Tight and Loose

Follow the instincts that tell you when to be a little wild with the paint and when to be tight and meticulous. By carefully outlining the white neon juxtaposed against the loose background, you create a tight and loose contrast in your painting.

Use Luminous Light for Mystery

A light at the end of a tunnel is an archetypal symbol of hope in the art and literature of cultures throughout the world. I came upon this scene while walking through a darkly wooded area of moss-coated trees and mushrooms and couldn't resist the pull of the light beyond.

All the paint mixtures throughout include a touch of odorless mineral spirits and linseed oil. In my painting example I eventually applied so much paint that the orange underpainting was completely obscured. The path I began ended a little differently than I intended. You may choose to skip the orange underpainting or paint in a manner that allows the underpainting to show through the finished painting.

Materials

Surface
Hand- or prestretched, 36" × 60" (91cm × 152cm) canvas (or smaller, if you like)

Brushes
1½-inch (37mm), ½-inch (12mm) and ¼-inch (6mm) stiff bristle flats

Paints
Burnt Sienna, Cadmium Orange Deep, Cadmium Red Deep, Cadmium Yellow Deep, Cerulean Blue, Ivory Black, Phthalo Green (Yellow Shade), Quinacridone Magenta, Titanium White, Ultramarine

Other
Coarse pumice gel
Gesso (if canvas is not primed)
Mixing container
Odorless mineral spirits
Straightedge

Do Water and Oil Mix?

Gesso and gel are water-based products. It's acceptable to apply oil paints over water-based gesso and gels (after they dry). But water-based acrylic paints should never be applied over oils—the binders are not compatible.

Reference Photo

1 | Prepare the Underpainting

If your canvas is not primed, apply a coat of gesso with a moderate amount of coarse pumice gel to give the surface a grainy texture. The grainy surface provides texture but is not essential to the painting, so you can omit the pumice gel if you like. Let the canvas dry overnight.

Apply a thin, mottled coat of Cadmium Orange Deep with a light mixture of odorless mineral spirits and refined linseed oil.

Divide the reference photo and canvas into grid squares, then draw in the picture's basic lines to guide you as you paint. No need for detail at this point.

2 | Block in the Basic Values and Shapes

The reference photo has a strong light portion, a strong dark portion and middle range of values that connect them. Begin blocking in the basic value ranges and colors using a ½-inch (12mm) bristle flat. Use various shades and tints of Phthalo Green (Yellow Shade) for the foliage, and browns like Burnt Sienna for the path. Let hints of other colors such as Cadmium Yellow Deep, Cadmium Orange Deep and Quinacridone Magenta mixed with Ultramarine find their way into your color mixes to create complexity and nuance. Don't worry about details right now.

3 | Continue Blocking In

The foliage closest to the light is lightest, so mix more Titanium White into that green. Continue blocking in various light, medium and dark values. Use large strokes with a ½-inch (12mm) flat to cover more canvas quickly. Add hints of other colors as you go, such as Phthalo Green (Yellow Shade), Cadmium Yellow Deep and Ultramarine.

4 | Establish Distant Foliage and Textures

The sunlight breaks through the trees and appears to partially consume the trees closest to the light source. As you paint the distant foliage, add more white with hints of yellow and purple using the same colors you did in step 2. With the ½-inch (12mm) flat, emulate the general texture of the foliage using progressively darker green shades closer to the foreground.

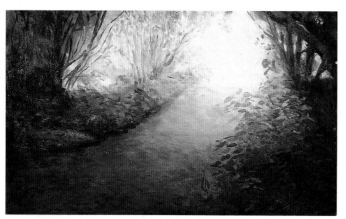

5 | Establish the Overall Foliage Textures

Add some cool pinks with tints of Quinacridone Magenta and purples with mixtures of Quinacridone Magenta and Ultramarine nearest the light source. Zoom in to local areas in the reference photo. With this layer, you'll add more detail. Begin painting values and shapes you see in the reference photo with the ½-inch (12mm) flat. Continue from one local area to the next until the entire canvas broadcasts a layer of foliage detail and definition.

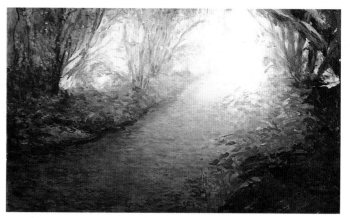

6 | Create the Nuance and Richness

The reference photo is somewhat out of focus, so many details are indistinguishable. To compensate for this, use progressively smaller brushes as you get closer to finishing. Doing so will create the illusion of details and a sense of shimmering light. You can also add dabs of colors that are not in the photo but are complimentary. The eye will mix the colors, creating nuance and richness.

Using the ½-inch (12mm) and ¼-inch (6mm) flats, dab without getting too literal. Move quickly and let your intuition and spontaneity guide you as you mix and dab Cadmium Yellow Deep, Ivory Black, Phthalo Green (Yellow Shade), Ultramarine and Titanium White.

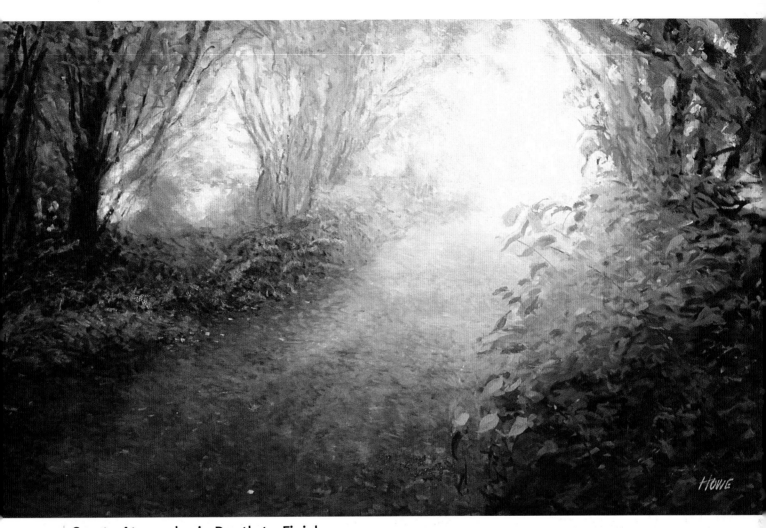

7 | Create Atmospheric Depth to Finish

Objects in the distance appear to soften. In painting, when you soften distant objects, it produces more atmospheric depth. Begin softening the background light by *dry-dragging* your brush with Titanium White, giving the background sunlit areas lighter values. That is, drag your brush on the canvas rather than stroking or dabbing. It leaves irregular deposits of color that catch on the hills of the pumice gel and will appear to lighten the color underneath, while allowing hints of the underneath color to show through.

Also, paint with larger dabs of color at the bottom of the painting and progressively smaller dabs toward the top of the painting. This helps create a sense of scale and perspective.

Caution

When dabbing paint, do so in a random pattern and with a variety of dab sizes and colors. You want to avoid a polka dot effect.

Size Can Control Depth

Larger objects and dabs of color always appear closer to the viewer than smaller objects and dabs of color.

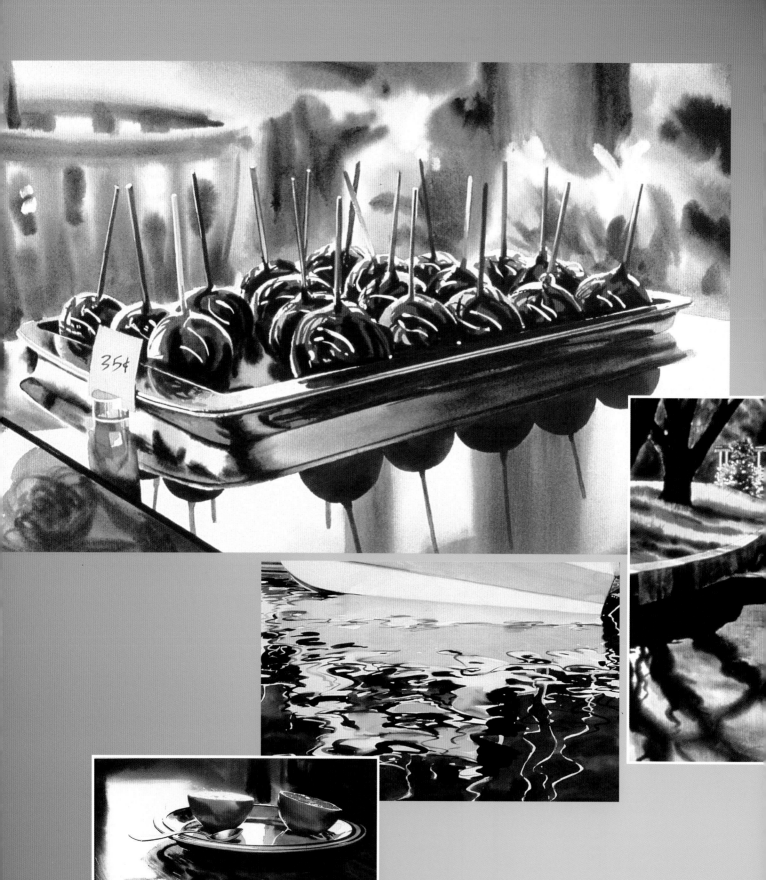

5

Light and Reflection

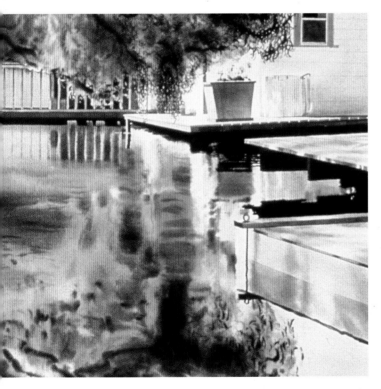

Light and reflection are age-old symbols (often found in poetry, literature and art) of mental or spiritual illumination and self-observation. They have also been used in art throughout history solely because of their beauty.

Reflections always increase the sense of light in a painting and help describe the kind of surface upon which the reflection is cast. In this chapter you will learn to paint direct and indirect sunlight, as well as reflections that shimmer and tantalize.

Combine Techniques to Paint Reflection

When it comes to watercolor painting, creating reflections involves using techniques you've already learned: wet-on-dry and wet-on-wet. Once you've got a handle on these, you need only remember a couple of reflection rules.

There are two universal basics of painting reflections:

- All reflections are a reversed or inverted image of the subject being reflected.
- The reflected image always assumes the texture of the surface upon which it is cast.

Use Wet-on-Dry for Hard Edges

Draw an apple and paint it red. While the paint is still a little wet add black into the red at the middle and bottom to make shadows. Add a black stem at the top.

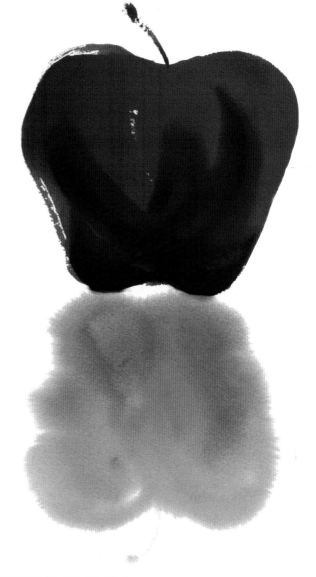

Use Wet-on-Wet for Soft Edges

Wet an area of paper. When the paper has dried somewhat but still has a wet sheen to it, paint an apple in the same manner as before, letting the edges bleed.

Together the Techniques Create Reflection

Paint the first apple again. Rotate the paper so the apple is upside down and paint the soft apple again (but lighter this time) creating an apple with a soft reflection below.

Anatomy of Reflections

Water has always been a favorite subject for artists and art enthusiasts alike. This chapter is devoted to painting light and reflection—there's no more naturally reflective surface than water. The key elements to painting reflections are: textures, patterns and shapes. Foreground water reflections are easiest to paint when thought of as shapes; middle ground reflections, as patterns; and background reflections as textures.

Use texture to paint background reflections

Use pattern to paint middle ground reflections

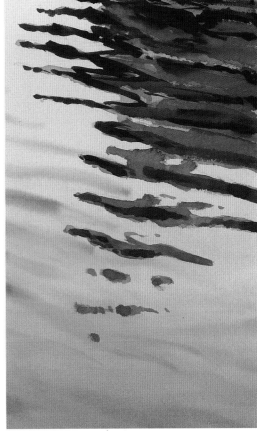

Use shapes to paint foreground reflections

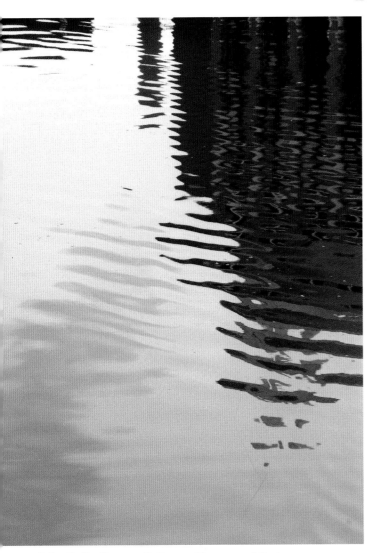

Paint Reflections as Patterns, Shapes and Textures
Waves always appear larger in the foreground and become progressively smaller toward the object being reflected.

Paint From Your Imagination

In this demonstration you'll practice using light and reflection but you'll throw away the reference photo (except for a tree) and paint from imagination.

Your subconscious mind is full of images stored there from your experiences. Combine a few of the images from your memory banks and the information you've learned so far in this book to create a river scene that demonstrates brilliant light and water reflections.

Reference Photo
The goal in this demonstration is to incorporate this tree shape into a water reflection scene created from your imagination.

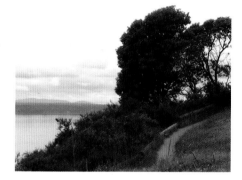

Materials

Surface
18" x 24" (46cm x 51cm) canvas board

Brushes
¾-inch (19mm), ½-inch (12mm), ¼-inch (6mm) stiff flats, no. 2 round

Paints
Burnt Sienna, Cadmium Yellow Medium, Ivory Black, Phthalo Green (Yellow Shade), Titanium White, Ultramarine Blue

Other
Medium
Mixing container
Odorless mineral spirits

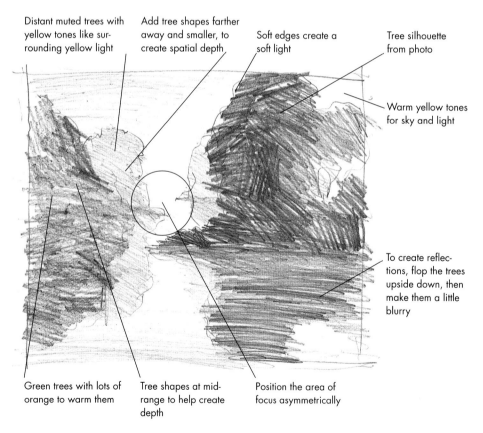

Distant muted trees with yellow tones like surrounding yellow light

Add tree shapes farther away and smaller, to create spatial depth

Soft edges create a soft light

Tree silhouette from photo

Warm yellow tones for sky and light

To create reflections, flop the trees upside down, then make them a little blurry

Green trees with lots of orange to warm them

Tree shapes at midrange to help create depth

Position the area of focus asymmetrically

Plan Your Painting from a Rough Sketch
To start, here is sketch of what I am imagining, along with a tree shape that I want to use. The sketch can be very rough because you need only draw the composition. Plan out exactly what you'd like to do at this stage to give yourself a map of sorts to follow as you paint.

1 | Begin the Sky and Reflection

Imagine a warm, hazy light. Its source is in the distance. Using a ¾-inch (19mm) flat and a mixture of Titanium White and Cadmium Yellow, paint the shape of the sky and distant light. Use a good amount of medium and paint the reflection of the sky in the water as well. Add touches of Ultramarine Blue at the top and bottom.

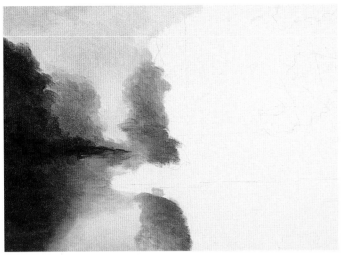

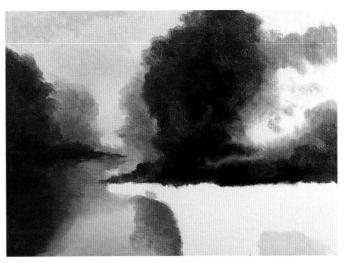

2 | Begin the Trees

The trees closest to the distant light take on the light's brilliant qualities. Using a ½-inch (12mm) flat and Cadmium Yellow Medium, Phthalo Green, Titanium White, Ultramarine Blue mixtures with a good amount of medium, paint each tree as a separate shape but add softness to the edges (page 23) and textures to the interiors. Let the tree's edges blend a little with the surrounding sky shape. Paint the tree reflections in the water with horizontal strokes that blend together using Phthalo Green, Ultramarine Blue and Ivory Black. Add more Ultramarine Blue to the sky.

3 | Paint the Foreground Trees

Paint the closest trees with the most color saturation and detail. Paint a warm yellow light coming through those branches. Make the closest trees the largest, the fullest and the most dramatic. Add Ivory Black to make deeper, darker colors in the foreground, always maintaining soft edges.

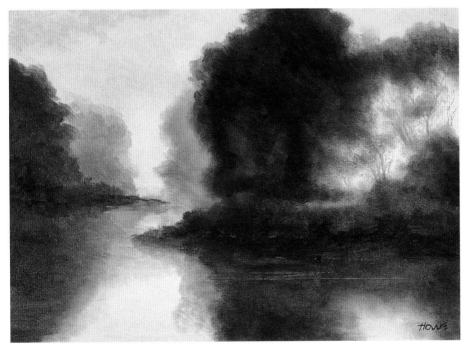

4 | Finish the Shadows

Imagine the foreground trees have a large, cool shadow that fills the foreground water. Add more intense color using Phthalo Green, Ultramarine Blue and Ivory Black with a small amount of medium now, use shades of blue to enhance the shadows, too—shadows love blue. Add branches with a no. 2 round to give only a hint of detail.

Paint a Sun-Filled Scene With People

In Rome, and in every small hill town throughout Italy it seems, the food, wine and hospitality are warm and wonderful. This outdoor café scene captures that warmth with sun coming from the right, but also offers an indirect diffused light that fills the space too. The reflections on the stone floor are soft and add important contrast and balance to the other textures in the scene.

Materials

Surface
Arches 140-lb. (300gsm) cold-pressed paper, full sheet

Brushes
Chip brush, 1-inch (25mm), ½-inch (12mm), ¾-inch (19mm), ¼" (6mm) flats, ¼" (6mm) flat oil bristle, no. 2 round

Paints
Alizarin Crimson, Burnt Sienna, Cadmium Orange, Payne's Gray, Ultramarine (Green Shade), Winsor Green (Yellow Shade), Winsor Yellow

Other
Masking fluid
White gouache

Reference Photo
In the reference photo, on the awning are the words "Snack Bar" in reverse. While helpful to English speaking tourists, the words diminish an otherwise rich image, so we'll simply pretend they aren't there.

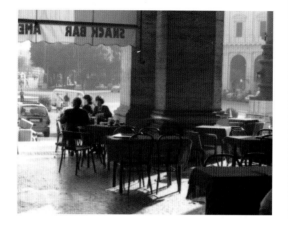

Prepare Your Drawing
No one will know if you draw the tables a little longer, shorter or taller; however, viewers will notice if the people are not proportioned correctly. Pay special attention to the relative scale of people, architecture and other things.

1 Begin the First Area

Divide the reference photo into about six large areas that you can work on individually, without having them touch each other. (If they touch they'll bleed into one another.)

Use the wet-on-wet technique and the 1-inch (25mm) and ¾-inch (19mm) flats for the upper left background and to capture the soft reflections on the stone floor foreground. Use mixtures of Ultramarine (Green Shade), Winsor Green, Burnt Sienna and Winsor Yellow to approximate the colors in the reference photo.

Use the wet-on-wet technique with a ¾-inch (19mm) flat and warm tones of Burnt Sienna, Alizarin Crimson and Payne's Gray for the top center pillars. Switch to a wet-on-dry technique with a ½-inch (12mm) flat for the lower right tablecloth and upper right doors and windows.

2 | Continue Blocking In

Move from big information to smaller information. When you establish big information (large colors and shapes), the small information (details) is easier to paint.

Flood the awning shape, then apply a wet-on-wet wash of greens made with Winsor Green (Yellow Shade) and Winsor Yellow using a ¾-inch (19mm) flat. Treat the tablecloths as connected shapes for now and fill them in with Alizarin Crimson. Add details to the upper right using a ½-inch (12mm) flat and a light tint of Ultramarine (Green Shade).

3 | Zoom In to the Upper Left Corner

The street in the background and the people at the table are the focus of this painting and are comprised of several small shapes that you'll need to keep from running together.

Rewet the background street in the upper left corner. Let it dry to a satin sheen. Add the smaller detail colors of the tree branches, auto details and street shadows using a ¼-inch (6mm) flat and mixtures of Ultramarine (Green Shade), Payne's Gray and Winsor Yellow. Take your time and make sure your people have the correct proportions.

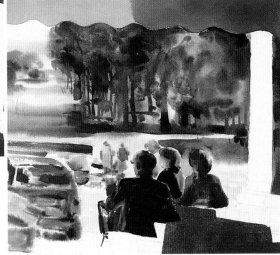

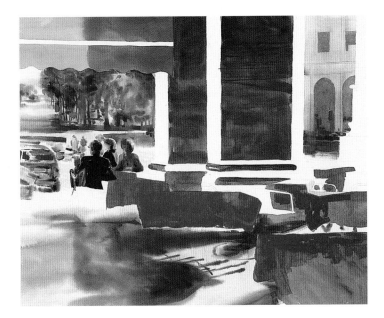

4 | Add Color Saturation and Begin Details

To intensify the floor colors, apply a clear water wash over the area again, then add more of those same colors. Paint thin lines to create chair leg shadows using a no. 2 round. Apply a light blue-gray wash over the background building area in the upper right corner with a ½-inch (12mm) flat. Add accents to suggest detail.

While you're waiting for the paint to dry, add some of the architectural details to the large central pillar.

Caution

If your paper is too wet, your details will be lost in a blur of blended colors.

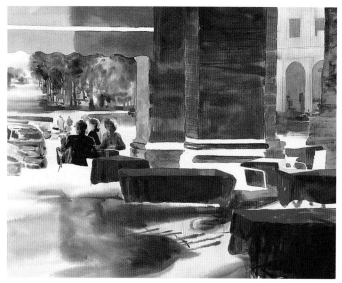

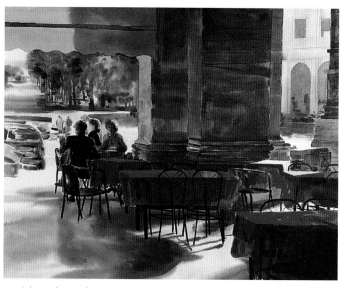

5 | Add the Shadow in the Tablecloths

Paint the remainder of the central pillar, the post at right and the shadows on the tablecloths using a ½-inch (12mm) flat in the wet-to-dry technique with mixtures of Alizarin Crimson and Payne's Gray.

6 | Paint the Chairs

With Payne's Gray, paint the chairs with a no. 2 round.

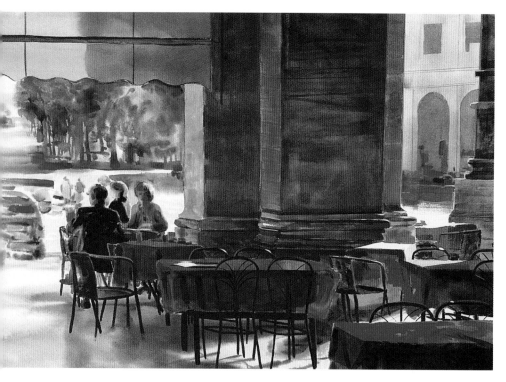

7 | Add the Finishing Touches

Zoom out, zoom in. Look at your painting from different points of view. Set it aside for a few days and come back to it with fresh eyes.

Use white gouache to add white sunlight highlights on the people and white highlights on the chairs. Make your painting sparkle!

Caution

Chairs and other symmetrically designed objects need to look symmetrical enough to fit the character of the painting. The more accurately you paint the architecture, the more accurate the autos, people and furniture must be.

Capture the Golden Light and Reflections of a Venetian Canal

No motorized vehicles are allowed in the city of Venice. The sprawling canals are Venice's streets. Motor taxis and merchants travel up and down the waterways. In this painting, you will capture the golden warmth of a Venetian canal.

You'll depart from the reference photo in two respects: You'll open up the horizon to create the sense of distant light, and you'll use a color palette that consists mostly of warm tones such as browns, reds, yellows and oranges.

Apply your paint to the palette and add a tiny touch of medium as you go. Stiff, square brushes are best for painting architectural elements. Remember, brushes do what they look like; a stiff, square brush will make stiff square marks, perfect for architectural elements.

Materials

Surface
32" x 48" (81cm x 122cm) stretched canvas

Brushes
¾-inch (19mm), ½-inch (12mm) and ¼-inch (6mm) stiff flats, no. 2 round

Paints
Burnt Sienna, Cadmium Orange, Cadmium Red, Cadmium Yellow Medium, Ivory Black, Titanium White

Other
Craft knife
Medium
Mixing container
Odorless mineral spirits
Packaging tape
Straightedge

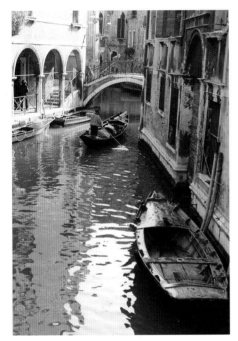

Reference Photo

Brush Tip

Always select brushes by how their bristles, or hair, resemble in appearance the size, shape and texture of the brushstrokes you wish to make.

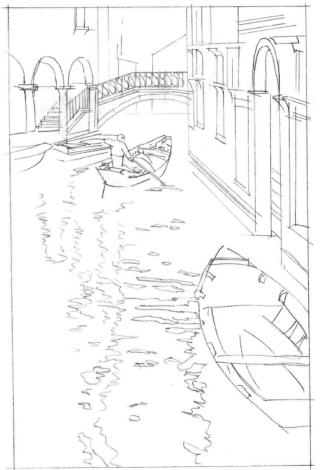

Drawing Detail
Don't worry if you have to erase and start over a number of times. You're in good company. The same drawing process is evident in many of the drawings of the great masters from Da Vinci to Van Gogh. Use a straightedge to get the architecture right.

1 Paint the Building at Right

The distortion in the reference photo shows the building slanting to the right. I straightened it because the imperfection didn't add any aesthetic merit.

Start anywhere on the building, adding Burnt Sienna, Cadmium Orange and Ivory Black where you see them. Add any other colors you imagine being there too. Use your ¾-inch (19mm) and ½-inch (12mm) flats to simulate the effects of brick and the rough stone textures. You're just roughing in right now, so details aren't essential.

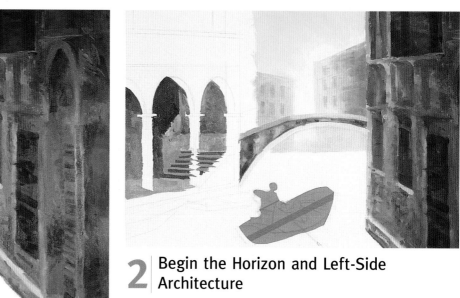

2 Begin the Horizon and Left-Side Architecture

Mask the gondola with packaging tape. Simply apply it over the drawing, then gently cut out the contour of the gondola with a craft knife. This will preserve the drawing and will help create the illusion that the surrounding water is behind and under the gondola. It serves the same function liquid mask does in watercolor painting.

Use light tones, with subtle shifts for the background buildings so they seem far away and overcome by distant light. For the horizon, use Titanium White with touches of Cadmium Yellow Medium, Cadmium Red, Cadmium Orange and Burnt Sienna. Use more saturation for the bridge because it's closer to the foreground.

Using the ½-inch (12mm) and ¼-inch (6mm) flats, make warm mixtures of Burnt Sienna and Ivory Black to begin the shadowed interior arches and stairwell.

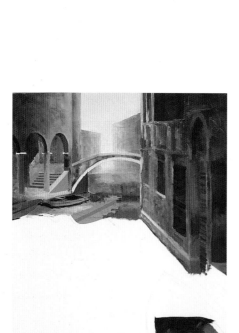

3 Build Up Tones for the Stucco Walls

Increase the color saturation by adding warm tones of Burnt Sienna, Cadmium Yellow Medium and Cadmium Orange. Create the wall texture by applying short strokes of Burnt Sienna and Cadmium Orange.

Use Ivory Black, Burnt Sienna and Ultramarine Blue to paint the inside of the gondola in the foreground. Indicate the parked taxis next to the arches.

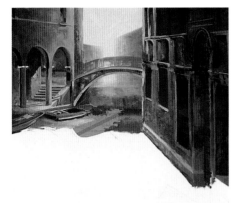

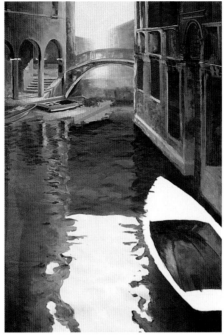

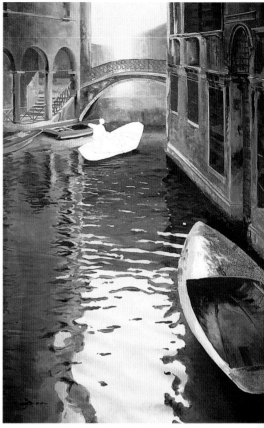

4 | Begin the Foreground Water Reflection

The water has a soft, undulating nature. Paint the waves larger in the foreground and smaller as they recede to the background using Titanium White, Cadmium Yellow Medium and Burnt Umber.

Use the side of an old flat brush to blend tones together. Use the same pale yellow color for the foreground water reflection that you used for the distant horizon. Add a little Burnt Umber to the pale yellow to get slightly darker shades.

5 | Paint the Waves and Water

The water in the foreground creates amorphous, blob-like shapes. The water in the middle ground, however, looks like a pattern of horizontal lines. Paint the background water as texture.

Apply the Burnt Umber, Ivory Black and Burnt Sienna liberally with a ½-inch (12mm) flat. Let the brush move and undulate like water. Apply the midtone colors first, then come back in with the lights and darks. Remove the masking from the gondola when you've finished.

Add more detail to the inside of the foreground gondola.

6 | Add Highlights and Details

Now that you've established the larger areas of water, you can add the smaller, middle ground pattern of waves using Burnt Umber, Ivory Black and a hint of Titanium White.

Add the bridge's iron railings and the railings on the stairs using the same mixture with a little more white. Use a straightedge to steady your hand and go slowly.

The midtones of the gondola in the foreground are Burnt Sienna, Titanium White, and a touch of Ivory Black. Make sure the white reflection jumps off the bow by keeping the edges of the strokes fairly sharp. Sharp-edged highlights always equal a glossy surface.

7 Paint the Main Gondola

Rough in the gondola using smaller flat brushes. Use Ivory Black for shades and make a gray-brown for the midtones using Ivory Black, Titanium White, Cadmium Yellow Medium and Burnt Umber. Let the paint dry between applications to keep the details crisp. Make sure the human proportions and gestures are correct.

Add more Titanium White and Cadmium Yellow to the highlights on the gondolier's shoulder. Use the pro paint-by-number technique, a ¼-inch (6mm) flat and a no. 2 round to establish the general shadows, midtones and highlights. Then carefully integrate them by blending their edges together somewhat.

8 Add the Final Details

Zoom out to see your painting as a whole. Zoom in to make sure the brush strokes have been executed with confidence.

Add touches of color here and there to punctuate the painting with highlights, shadows and details.

Using a no. 2 round, add architectural details and highlights throughout with Cadmium Orange and Cadmium Yellow Medium. Put sparkles of light tints of Cadmium Yellow Medium into the water.

Add more Cadmium Orange and Cadmium Yellow Medium with Titanium White on the sunny side of the far arches to brighten them up.

Add a board to cross the center of the front gondola with a a mixture of Burnt Sienna, Burnt Umber and a touch of Titanium White and Cadmium Yellow Deep. Allow your brushstrokes to be somewhat rough to simulate the texture of the board. Keep the outer edges sharp so the board clearly appears to overlap the boat's interior.

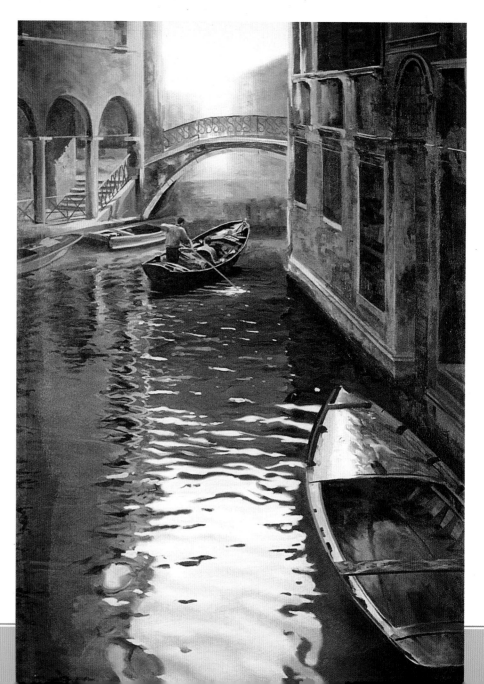

Another View of the Venetian Canal

Changing the orientation of a reference image from vertical to horizontal can change the story a painting tells dramatically. You have already painted this scene vertically; now you'll paint a horizontal version. The vertical version engages your attention through the brilliant foreground reflections of light. In the horizontal version, you'll crop out the foreground water reflection and focus the story more directly on the gondola and surrounding architecture. The story has become more intimate and personal.

In this watercolor painting, just as in the oil version, you'll depart from the reference photo in two respects: You'll open up the horizon to create the sense of distant light and use a color palette that consists mostly of warm tones, such as browns, reds, yellows and oranges.

Materials

Surface
140-lb. (300gsm) cold-pressed paper, full sheet

Brushes
¾-inch (19mm), ½-inch (12mm) and ¼-inch (6mm) flats

Paints
Alizarin Crimson, Burnt Sienna, Burnt Umber, Cadmium Orange, Cadmium Red, Cadmium Yellow, Cobalt Turquoise, Payne's Gray, Van Dyke Brown, Winsor Yellow Deep

Other
Masking fluid
Paper towels
Red, white, orange and yellow gouache
Straightedge

Reference Photo
Make a sketch of the image in a horizontal format this time.

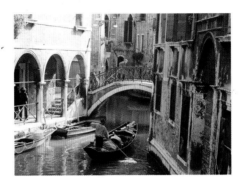

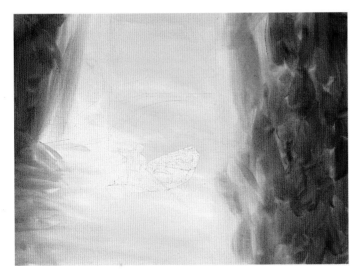

1 Apply Masking and First Wash

This canal image demonstrates an excellent example of when to use masking fluid. The gondola must remain separate from the surrounding water. By masking the gondola, you can play fast and loose with the surrounding water without fear of painting into the gondola's area. Apply an overall wash of water. Using warm tones and Cadmium Yellow, rough in the yellow highlights. Add soft, warm midtones of Winsor Yellow Deep and Burnt Sienna.

Mask Selectively

Use masking fluid only when you want really sharp edges; otherwise, just paint around whatever object's contour needs to be preserved. Masking sometimes results in overly sharp, hard edges. You never want an object to appear as though it was painted on a separate piece of paper, cut out and then glued onto the painting. Hard masking edges can have this effect.

2 Begin the Water Areas

Normally you would paint the buildings before painting the water because the tones and colors of the buildings determine the tones and colors of their reflections in the water. But in this case, begin with the water so you can remove the mask as soon as possible. The longer the mask stays on, the tougher it will be to remove.

Flood the area with water and let it dry to a semi-gloss sheen. Use Winsor Yellow Deep, Burnt Umber and Van Dyke Brown, beginning with the lightest tones and progressing to the darkest tones. Use a ¾-inch (19mm) flat on edge to emulate the water and waves. After it all dries thoroughly, remove the masking.

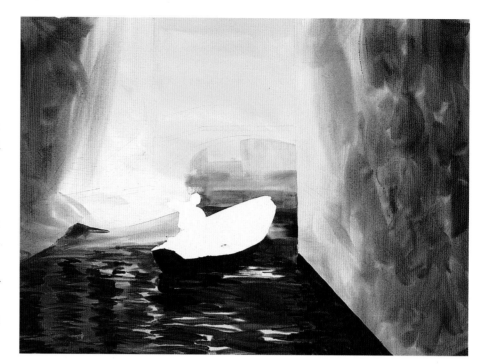

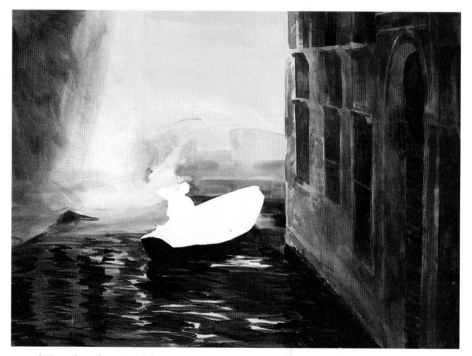

3 Begin the Architecture

Redraw some of the architectural details so they don't become too light to see. Draw lightly where you'll apply light tones of color to make erasing the lines later easier. Draw heavier, darker lines where you'll place dark tones of color so you can see the drawing underneath to guide you.

Use the wet-on-dry technique and mixtures of Burnt Sienna, Burnt Umber, Van Dyke Brown and hints of Winsor Green to apply patches of dark brown and black tones that overlap, creating the effect of old stone and brick. Add some Cobalt Turquoise here and there to compliment the rusty brown tones.

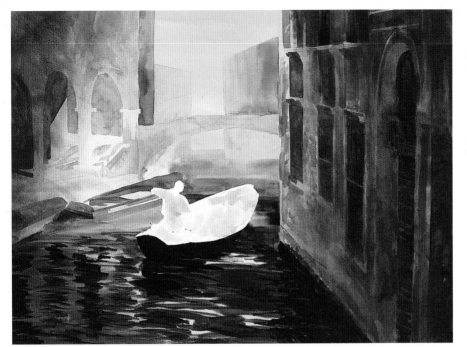

4 Begin Subtle Tones and Details

Now that you've established the overall larger areas of color, begin the smaller areas. Use ½-inch (12mm) and ¼-inch (6mm) flats and the wet-on-dry technique to add in shades of Cobalt Turquoise with Payne's Gray near and around the arches beyond the gondola from lightest to midrange. Add Cobalt Turquoise to the shadow areas. Use Burnt Sienna on the background boat.

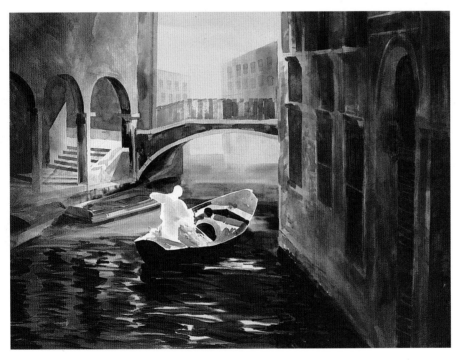

5 Continue Detailing

The railing on the bridge is very ornate and would be distracting if you painted every detail. Merely suggest the ornamentation with a simpler design.

Use orange and white gouache and Payne's Gray to suggest architectural details. If the bright yellow light in the distance looks too yellow, rewet it and dab out some paint with a paper towel.

The bridge and stairs at left inform the viewer of the scale. Begin adding the darker shades of Burnt Umber and Cobalt Turquoise to the stairs, but preserve the overall feeling of light that fills the stairwell by keeping your color light and soft. With a ¼-inch (6mm) flat and tints of Raw Umber, make vertical strokes that suggest a railing on the bridge. Begin adding in tones of Cadmium Yellow and Payne's Gray for the gondola.

6 Paint the Inside of the Main Gondola

Inside the gondola there is a gondolier and passengers, seat cushions, gear and supplies. You want to capture these details without getting too tight with the painting in the process. Use smaller brushes and the wet-on-dry technique. Paint the lightest tones first using tints of Payne's Gray, Cadmium Red and Burnt Umber. Let them dry, then paint the darker tones by layering in heavier amounts of Payne's Gray.

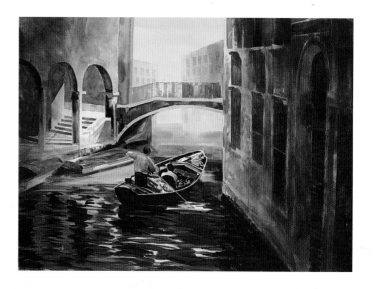

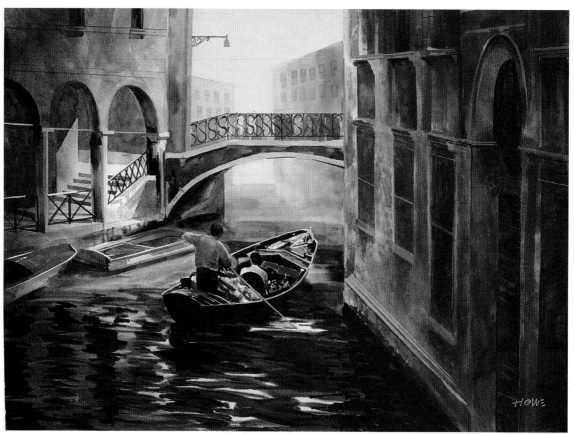

7 Add the Finishing Details

When you're finished with the stairs at left, add the railings and other architectural details. Add white gouache mixed with Cadmium Yellow to create highlights. For the railing details on the bridge, add S-shaped ironwork using tints of Burnt Sienna. This will suggest an ornate railing design without overcomplicating things. Use white gouache for the brightest highlights in the gondola.

Caution

Avoid the temptation to put stripes on the gondolier's shirt, as the reference photo shows. That sort of tiny, sharp detail will draw more attention to the shirt than you want.

Water Reflections Capture Rich Texture and Nuances

This bridge, which connects a group of floating homes to the shore, tells the story of how textures of foliage and water reflections interact with light. It's composed mostly of textures. The elements of greatest aesthetic merit in order of importance are:

- The central light and the value ranges it creates affect the surrounding shadows. If you capture these, all other sins will be forgiven.
- The rich textures, which you'll create by dabbing the paint. This only takes patience.
- The wiggling horizontal lines of the bridge's reflection.

The color scheme is important too, but in this picture, the painting will still look great even if the hues are a bit off. The same is true of the bridge and building; even if you rendered them architecturally inaccurate, the effect would give the painting a different character without diminishing the success of the whole.

In previous lessons you've learned the basics of backlighting and reflection. In this demonstration you will learn about the complexity of foliage that surrounds a scene with those qualities.

All the paint mixtures include a touch of odorless mineral spirits and linseed oil.

Materials

Surface
Hand-stretched or prestretched, canvas (My example is painted on a 36" x 60" [91cm x 152cm] canvas, but I recommend you try something smaller.)

Brushes
¾-inch (19mm), ½-inch (12mm) and ¼-inch (6mm) stiff bristle flats (Use the wider brushes at the beginning for broad strokes, and more narrow brushes as you move toward finishing for details.)

Paints
Burnt Sienna, Cadmium Orange Deep, Cadmium Red Deep, Cadmium Yellow Deep, Cadmium Yellow Medium, Cerulean Blue, Ivory Black, Phthalo Green (Yellow Shade), Quinacridone Magenta, Titanium White, Ultramarine Blue

Other
Coarse pumice gel
Gesso (if canvas is not primed)
Medium
Mixing containers
Odorless mineral spirits
Refined linseed oil
Straightedge

Photo Reference
The lines of the architectural elements—the bridge and the building at right—form the primary structural lines for reference. The light is strongest in the middle of the image and becomes darker toward the outer edges.

Caution

To paint the structure, draw the longest lines first to continually segment the composition into smaller shapes, which will help you place the smaller lines with increasing precision. The more accurately you place the long lines, the more precise the short ones will be.

1 | Prepare the Surface and Drawing

If your canvas is not primed, apply a coat of gesso with a moderate amount of coarse pumice gel (omit the pumice gel if you like) to achieve a grainy texture. Let it dry overnight.

Apply a thin, irregular coat of Cadmium Orange Deep with a mixture of odorless mineral spirits and refined linseed oil. Let it dry.

Draw a grid on the reference photo: three squares up and five across, fifteen total. Number each square from one to fifteen. With a soft pencil, lightly draw your grid lines on the canvas to match those on the photo. With the edge of a flat brush and black paint, draw the longest lines of the structure first and progress to the shortest lines.

2 | Begin Painting the First Square

Paint from the general to the specific, one grid square at a time. Start with grid square 15 in the right lower corner. (I often start here because it's the most natural starting position for a left-hander. If you're right-handed, it may feel more natural to start at the upper left square).

Add Cerulean Blue to Titanium White to achieve the lightest blue tint. For the darker tones add Ultramarine Blue to the Cerulean Blue. For the green tree reflections, add Phthalo Green (Yellow Shade) to the Cerulean Blue. Use Ultramarine Blue and Ivory Black for the darkest tone. For the highlights, use Titanium White and a touch of Cadmium Yellow Deep. Refer to the reference photo as you go. Don't worry about the order in which you apply the color. You'll revisit each grid square later. Let some of the orange undertone show through.

Why Grid Painting Works

It's easier to paint several small paintings that will eventually come together than to tackle one large picture all at once. Imagine that each grid square is a painting unto itself. Forget for a moment the complexity of the entire image and focus on an individual grid square. Your field of vision narrows and your task becomes easier.

Grid Square 14 Reference

3 | Paint Grid Square 14

This grid has lot of white and is a perfect example of white being light. Unlike watercolors, which often require a plan, oils do not dictate your actions. So basically, continue using the same colors you applied in step 2 in the same manner. Don't worry if what you do is not perfect; perfection's somewhat overrated anyway. Just work from the general to the specific. At this point, you're establishing the general colors and compositional structure of the painting. Continue to apply values of colors as you see them in the reference photo.

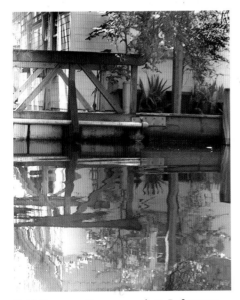

Grid Squares 8, 9, 10 and 13 Reference

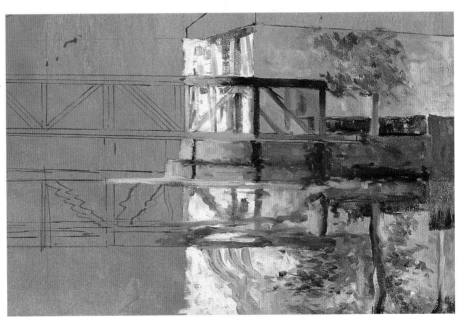

4 | Paint Grid Squares 8, 9, 10 and 13

The colors become warmer with hints of Quinacridone Magenta, Burnt Sienna and a purple mixture of Quinacridone Magenta, Ultramarine and Titanium White as you move from below the waterline to above it. Begin blocking in these colors as you see them using a ½-inch (12mm) flat. And, remember, it's OK to imagine colors that aren't there.

As you move above the waterline (squares 9 and 10), add in hints of Cadmium Red Deep. Block in the largest shapes first and be alert to value changes. Remember to let the orange undertones continue to show through.

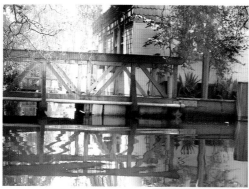

Grid Squares 3, 4 and 5 Reference

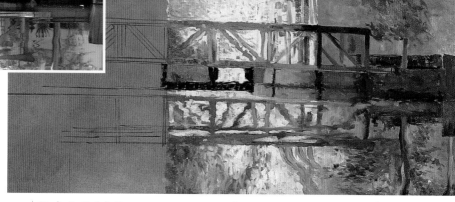

Grid Squares 2, 7 and 12 Reference

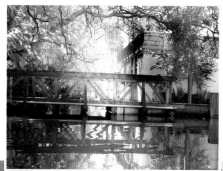

5 | Paint Grid Squares 3, 4 and 5

The white in the center of the reference photo is strong. You want to capture that in your painting. Remember, objects close to a light source take on the brightness of that light source. Continue roughing in areas, defining shapes and colors in general using wider ¾-inch (19mm) and ½-inch (12mm) flats and the established colors: Ultramarine, Ivory Black, Titanium White, Burnt Sienna, Phthalo Green (Yellow Shade). Add a little Cadmium Yellow Deep into the green foliage along with a touch of Cadmium Red Deep.

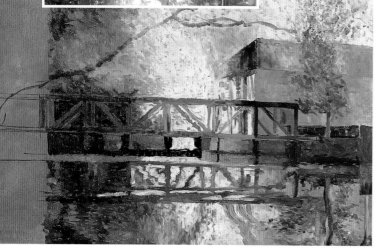

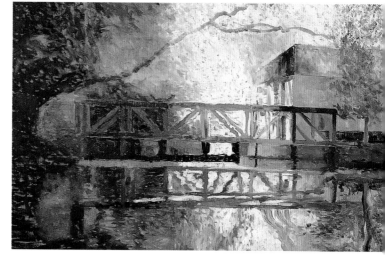

6 | Paint Grid Squares 2, 7 and 12

The value ranges, in general, are darker in these squares. Some of the darker tones are close in color and value. Other than the structure of the bridge, these squares are almost all texture (dab the paint) with hints of shapes in the water reflection below and tree leaves above. Use the established colors to rough in these shapes, colors and values with the wider ¾-inch (19mm) flat.

7 | Paint Grid Squares 1, 6 and 11

These squares are mostly dark with texture, though some of the broader leaves form shapes. Paint the broad leaves at the foreground later, since they overlap the dark tones of the background.

Apply the general tones of the textures with short choppy strokes and shades of Phthalo Green (Yellow Shade) mixed with Ivory Black, allowing the orange underpainting to show through.

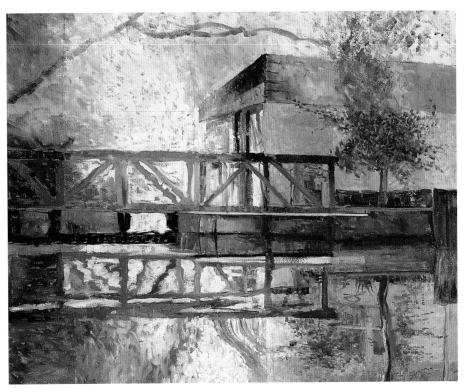

8 | Begin Refining the Right Side

Now that you've roughed in the image, start thinking of the painting in terms of left side, middle and right side. Look a little closer at the photo and your painting to notice the colors, values and shapes more specifically.

Use a ½-inch (12mm) flat to apply the basic colors as they appear in the reference photo. Use Phthalo Green (Yellow Shade), Ivory Black, Titanium White and a touch of Ultramarine Blue for the green of the tree in the water's reflection. Replace the touch of Ultramarine Blue above the waterline with a touch of Cadmium Red Deep, shifting the palette from the cool tones of the water to warmer tones above. Dab the paint, creating little chips of color. Where possible, let the underlayers show through.

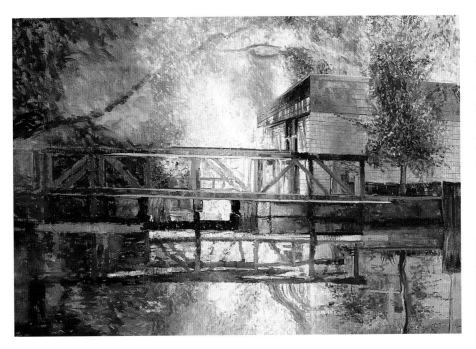

9 | Refine the Middle of the Painting

Using the ½-inch (12mm) flat, continue dabbing with the same colors you used in step 8. Work to capture the subtle value shifts in the reference photo. Many of the value changes in this portion of the painting will be very slight.

Taking Stock

So how are you doing so far? When you step back, your painting should look somewhat like the reference photo, only a lot rougher. The colors will be muted and a bit disorganized.

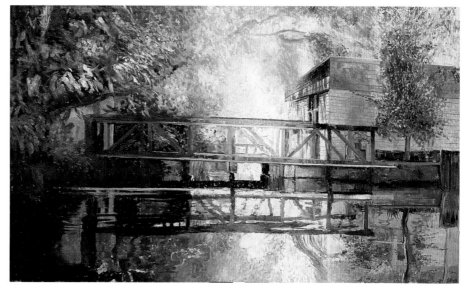

10 | Refine the Left Side

This last section is full of darks. Distinguish in your mind's eye where you'll render leaves as shapes and where as textures. Play with the color. It doesn't matter if the green leaves have a blue, orange or red cast. Experiment with different tints of green. All these effects can be beautiful. What matters most is that the colors are the correct value. Use Phthalo Green (Yellow Shade), Cadmium Yellow Deep, Cadmium Orange Deep and Ivory Black.

Really let go on the trees. Think of it as abstract painting. Move quickly as you dab and stroke. Take it as far as you can without the paint getting muddy.

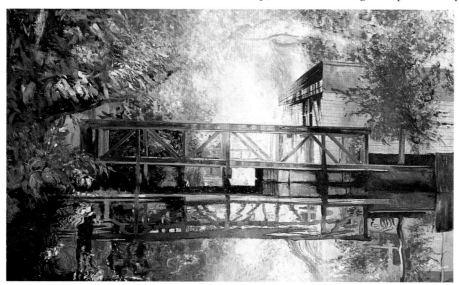

11 | Refine the Painting Overall

The darks aren't dark enough yet. Use a ¾-inch (19mm) flat to lay in the darker tones where you see them. It is more important to lock in the dark values than to fine-tune the brush technique or textures right now.

The foliage shadows need Ivory Black, and a mixture of Ivory Black and Phathlo Green for the darkest greens. Use Ivory Black for the shadow under the bridge. That will make the sunlight all the brighter. The tree at right and its reflection need clear steps between lights, darks and midtones. For the lights add Titanium White and Cadmium Yellow Medium, for mid-tones add Phthalo Green and Cadmium Yellow Deep, and hints of Cadmium Orange Deep. For the darks (shadows) add Ivory Black.

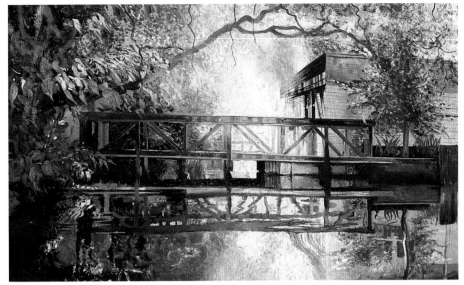

12 | Paint the Branches and Leaves

The branches are dark in some places but very light in others. As you look at the reference photo, notice where the leaves are dabs, where they are small brushstrokes and where they are large brushstrokes. The foliage areas are black, dark green, light lime green, pale yellow and white. Paint in just the primary branches, not all of them. The order in which you apply the color doesn't matter, so proceed at will, painting in the various sizes of leaves with your leaf colors, which are: Phthalo Green (Yellow Shade) with Cadmium Orange Deep, Cadmium Yellow Deep and Titanium White.

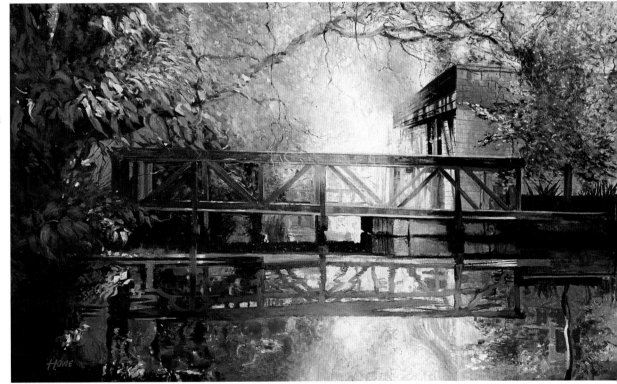

13 | Brighten the Foliage to Finish

Now that the values are firmly in place, brighten up the green foliage to make the overall color, and the painting, a little more snappy. Using a mixture of Phthalo Green (Yellow Shade), Cadmium Yellow Medium and Titanium White, mix light lime-green tones. Gently apply the color by dry dragging it with the flat side of a ½-inch (12mm) flat.

Finding Inspiration

If you've made it this far through the demonstrations, you probably now know a heck of a lot more about painting than when you started—so congratulations! As you go forward from here I encourage you to always follow your curiosity. Remember that the pleasure and fulfillment of being an artist comes only as you embrace the beauty of the world around you through your eyes, mind and heart. It's all there; now we just need you to show us! New ideas will come to you when you're alert to your environment. Always look upon the world with an artist's eye. Fall in love with every quality of light nature offers. Here are some ways I use to find painting inspirations.

Repetition Can Be a Good Thing
Look for patterns and textures all around. Successful paintings often have repeated rhythms and textures.

Investigate the Old
Exploring antique shops can uncover great subject matter.

Alter the Familiar
Paint a familiar subject like flowers from an unusual angle with compositional arrangements you've never tried.

Invite Your Friends
Get your friends to pose for you. It's a great learning experience.

Focus on the Details
Let the details of scenes in nature inspire you. This rock wall, with its abstract quality, would make a great painting.

Explore Your Surroundings
Take long walks and explore new neighborhoods, always on the lookout for subject-matter gems. This arboretum is part of a walk I take often.

Go to the Beach
Standing at the edge of the sea is a must. The ocean is a never-ending source of inspiration.

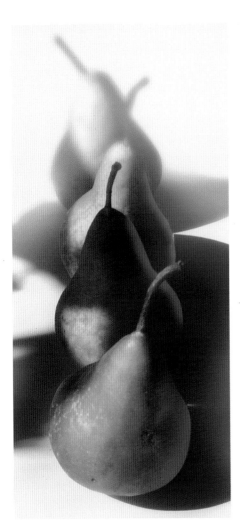

Twist Still Life
If you've never done still life painting, give it a try. But be daring and do it with a twist.

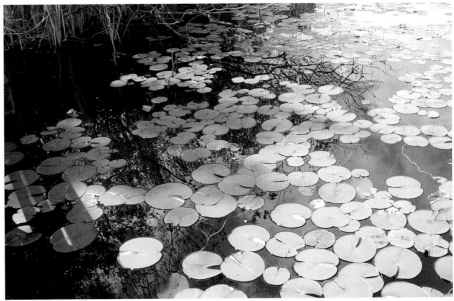

Emulate the Masters
Monet made water lilies famous. It's always fun to take the proven subject matter of great masters and try your hand at them.

Take Hikes
Get healthy while finding inspiration.

The Business of Art

Several books have been written to help artists prepare their portfolios and turn their love of art into a business. I highly recommend *Artist's & Graphic Designer's Market* (Writer's Digest Books) to get started. It's a comprehensive book that gives excellent advice to new and seasoned artists and illustrators. It covers such basics as how to approach galleries, art directors and publishers with your artwork. It offers copyright information and business advice. And if that's not enough, it also serves up hundreds of qualified leads with contact information of galleries and companies that are looking for new artists.

The following are personal observations and advice I offer, based on boots-on-the-ground experiences with art galleries and the business of art.

Persistence is Key

The first thing you need to know is that there is a glut of artists out there. For every artist whose work is hanging in a gallery or used in a commercial venue, there are a hundred equally qualified artists who can't get into galleries or commercial art directors' offices. So don't get discouraged when you get rejections. Assuming your work is salable, the odds are in your favor that you will eventually find some galleries that are a match for you.

It's Your Business

If you intend to sell your artwork—whether through galleries, coffee shops, art publishers, at fairs or from your studio—you are by default assuming the role of CEO of an art business. You are responsible for your own success. A simple truth is that an artist cannot succeed in business without embracing strategic business practices. Conversely, if you do, you may just live out your wildest dreams.

Dispelling a Myth

A common misconception in the business of art is that art galleries handle the business side of art so artists don't have to. An artist is supposedly freed up to focus on the task of making art. But the reality is that galleries do not manage an artist's business. They are not employed by the artist or obligated to meet sales and marketing goals for any of their individual artists. They are not accountable or responsible for the success or failure of any of their artists. And though there are rare exceptions in which patronizing galleries have assumed responsibility for the career success of artists they champion, by and large the goal of most galleries, like any other business, is their own success. Therefore any work that doesn't contribute to the gallery's bottom line will soon be replaced.

This is not to say galleries don't care if their artists succeed; they certainly do. But their interest is not charitable. It's a symbiotic relationship in which both parties benefit commercially until there is no longer a mutual gain.

Wet Tiles
Watercolor on 140-lb. (300gsm) cold-pressed paper
28" × 20" (71cm × 51cm)

I got this painting into a gallery by simply walking in with it and asking if they had any wall space. This is a dangerous technique, however. Most galleries require a submission of slides and find walk-in artists pushy and disrespectful of art gallery protocol. (I've been kicked out of a few galleries for trying it.) But what the heck, life's about adventure. No risk, no reward.

The Five Scariest Gallery Issues

I have asked many artists what they consider the scariest issues of dealing with art galleries. It always comes down to five things: contracts, exclusives, consignment, pricing and style restrictions.

Contracts

Most gallery contracts cover similar, fairly benign topics such as insurance, accountability and consignment fees. Read carefully to protect your rights. You are not obligated to sign a contract without question. You would not be offered a contract in the first place if the gallery weren't eager to work with you. Never underestimate your power to negotiate.

If you have questions after reading the contract, ask your gallery contact for clarification. If there are conditions that are unacceptable to you, write an addendum that restates those conditions in a manner that is acceptable, then attach it to the contract. If a gallery is inflexible and unwilling to accommo-

date at least some of your concerns, that's a red flag for your future relationship with them.

Exclusives

Some galleries require an *exclusive*, which is the exclusive right to sell your artwork within a given geographical area. Galleries might require a citywide, local regional, statewide or national regional exclusive. The purpose is to protect a gallery's (or art publisher's) investment dollars in branding the artist's name and artwork.

It would be unfair if a gallery purchased advertising for a show of an artist's work, then found the artist has very few paintings to put in the show because he's also selling them in a gallery across the street. Art is a retail product, but it is not mass-produced. Therefore the retail sale of artwork has to be guarded somewhat to protect the investment of the retailers.

However, unless a gallery can actually demonstrate a significant marketing and sales presence in an area for which an exclusive is expected—with sales representation, advertising and clientele—it is unreasonable. On the other hand, if a gallery starts to sell lots of your paintings, it would be smart not to make a stink about exclusives.

Most galleries do not start an artist off with an exclusive anyway, and some don't require them at all. Usually, they test-drive the art, so to speak, for several months to see how it sells, before discussing an exclusive. If it comes to that, again, do not underestimate your power to negotiate.

What Should Be in the Contract

If these items are not in the contract, add them.

- Request notification of sale within a week of the sale. Most galleries pay within thirty to sixty days. It's a professional courtesy to notify you of a sale, so you can project your monthly income.

- If the customer fails to make payments to the gallery for a purchase, you will nevertheless be paid in full. (It's your legal right.)

- If the gallery goes out of business, the artwork will be returned promptly and cannot be seized by creditors. The artwork is your property, not the gallery's. (This, too, is your legal right.)

- This topic's a little touchy for galleries, but it's important: If the gallery goes out of business, the names and contact information of customers who purchased your artwork will be given to you. For good reasons, galleries are proprietary about their client lists and are unlikely to release them easily. However, an art career is built upon a few customers who often buy, over time, several of an artist's paintings. You have a right to continue developing client relationships upon which your livelihood depends if the gallery is unable to. Your livelihood is in the hands of the gallery, and you are depending on the gallery for your income. Your livelihood should not be jeopardized because of the actions of the gallery.

Style Restrictions

Among actors there's the saying: Movies are a director's medium and the stage is an actor's medium. That's because in movies, directors control everything, including the actors. On stage, however, once the curtain goes up, the director is powerless.

The same is true in the art world. Art galleries are the gallery dealer's medium. They call the shots as far as how they operate their galleries. They select what artwork they will show. Some artists are afraid they'll have to paint in only one style, medium or subject to please the dealer. This is where you'll need some business acumen. In business you have to work with people, and you have to decide in what situations you should be flexible and when to walk away. I always try to work with a gallery's preferences, giving them what they want, provided I am not expected to compromise my creative interest and direction.

Consignment

Most galleries do not buy the artwork they sell; rather, they sell art on consignment. The artist provides a gallery with artwork and is paid only when the artwork is sold. Consignment benefits the gallery because, unlike most other retail businesses, galleries are not paying for their product inventory. Their stores are filled with merchandise at no expense to them, which is a tremendous advantage over other retailers. It's a disadvantage to artists because they have to wait to be paid for the inventory the gallery carries. If an artist has several galleries, the cost can be enormous.

On the other hand, if the consignment arrangement did not exist, neither would most galleries. Artwork is unlike other products. Most other products are test-marketed and have sales histories from which a retailer can estimate projected sales, thereby exposing his inventory investment to very little financial risk. But individual works of art are not test-marketed and, at least in the case of originals, have no sales history. There's no way of knowing if a particular work of art is going to sell.

Consignment percentage splits vary. The average consignment fee ranges from a 65/35 split (with 65 percent of retail sales going to the artist and 35 percent to the gallery), to a 50/50 split.

This example illustrates both a transparent and a luminous subject. The most saturated colors, such as the blacks, jump forward, as do its hard edges. The soft-edged shapes appear to recede into the background. This contrast creates spatial depth.

Jar of Flowers
Watercolor on 140-lb. (300gsm) cold-pressed paper
18" × 24" (46cm × 61cm)

Links

www.artistsmagazine.com
Business and art tips, articles and links to artist's sites

www.artsresourcenetwork.org
Lots of info for artists

www.art.weblogsinc.com
Commentary on the business of art

www.artsmarketing.org
Art marketing tips

Pricing Your Art

Let's consider what it will cost to produce a single painting (see pie chart). Keep in mind these figures are approximate. Also, if an artist does not work through a gallery and chooses to self-promote, then the artist is assuming the role of intermediary between the artist and customer, and the expense of doing so will be about the same.

Retail price of a single painting **100%**

Gallery consignment fee **40%**

"Take Home" Amount **25%**

Supplies **20%**

Federal Taxes **15%**

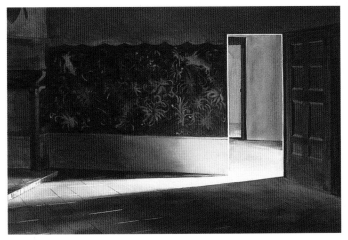

By the time I was ready to sell this painting, I had established a sales history and so was able to set the price based on that.

Italian Tapestry
Watercolor on 140-lb (300gsm) cold-pressed paper
20" × 13" (51cm × 33cm)
Private collection

If taking home only 25 percent of the retail value of your artwork sounds a little depressing, take heart. In business terms, a 25 percent profit margin is very respectable!

Keep in mind when setting your prices, you want the retail price to be enough that 25 percent would be a satisfying amount of money to take home.

Pricing Criteria

If you were Oprah Winfrey or Donald Trump, you could draw doodles of stick people on napkins and any gallery would gladly and easily sell them for a handsome profit. Why? Because of their reputations and the brand recognition their names have. It is *who* they are that gives their doodles value, not their artistic talent. A reputation (the bigger the better) will affect the price of your artwork more than anything else. However, if you are not yet famous, here are some practical guidelines that may help you price your artwork.

- **Comparable market value.** Go to galleries or search online to price artwork similar in size, style and quality to yours. From that, calculate a price per square inch and apply that price per square inch to your artwork. (Adjust for framing.)
- **Subjective value.** Ask yourself what you instinctively sense your painting is worth. Any artist would gladly accept millions for a painting, but back on planet Earth, think about what reasonable amount would convince you to part with your artwork.
- **Commercial appeal.** Is your painting in a style, technique and of a subject matter that others connect with? Adjust your price up or down according to its estimated appeal to other people.
- **Aesthetic value.** Was it executed well? Would other artists say of your painting "Now that's a good painting!" Adjust your price up or down according to how well it was painted.
- **Time and Materials.** Track your hours as you paint. Multiply the hours by a rate you think your time is worth. Include material costs.
- **Size counts.** Increase the price if the painting is large and/or complex. People expect to pay more for art that is large or complex.

Index

In this painting, the background, where the light is strongest, is overtaken by the light, creating an overexposed effect. Luminous lighting requires that the light appear overpowering. Lots of white and soft glowing edges help.

Ice Cream Parlor
Watercolor on 140 lb. (300gsm) cold-pressed paper
18" × 24" (46cm × 61cm)
Private collection